HIGHLIGHTS

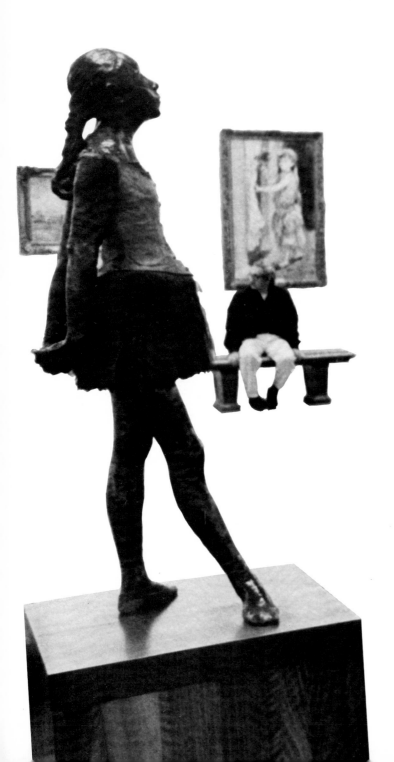

The publication of this book has been substantially supported by a grant from the National Endowment for the Arts in Washington, D.C., a Federal agency.

HIGHLIGHTS
Sterling and Francine Clark Art Institute

John H. Brooks
Associate Director

Sterling and Francine Clark Art Institute
Williamstown, Massachusetts

Library of Congress
Catalogue Card Number 81-80217

International Standard Book Numbers
Hardbound ISBN 0-931102-16-2
Softbound ISBN 0-931102-17-0

COVER
Claude Monet, *The Cliffs at Etretat*, 1885
(Number 27)

Preface

Many years in the making, this guidebook has been brought to fruition at a time of celebration for the Institute, its twenty-fifth anniversary. This is the last of three publications issued to help commemorate this special occasion. *Three Cheers for the Twenty-fifth* served as a catalogue for the 1980 summer exhibitions assembled to highlight the Clarks' collection of master drawings and antique silver and Mr. Clark's interest in horses. *1955-1980: A Twenty-five Year Report* chronicled the history of Mr. and Mrs. Clark as collectors, the founding of the Institute, and the major developments, activities, and acquisitions since opening to the public in 1955. This guidebook offers a sampling of the most important works of art now at the Sterling and Francine Clark Art Institute.

One of the hardest tasks an author has in a book of this kind is deciding what should be included. The selection of only forty-two items forced some difficult choices. In general, quality was the primary consideration, but weight was also given to presenting a balanced overview of the range and nature of the Institute collections. However, a notable exception had to be made in the case of Renoir. To select for inclusion only three of the thirty-seven Renoirs which the Clarks acquired is not fair to their favorite artist, nor is it consistent with the policy of selecting works of high quality, for there are numerous fine Renoirs.

The selection of items to be included here has been limited primarily to paintings. Other media in which the Institute's collections are significant are represented by only token examples. Two entries for old English silver suggest the extensive holdings in that area. A 1964 catalogue raisonné by Egbert Haverkamp-Begemann, Standish B. Lawder, and Charles W. Talbot, Jr., records and illustrates all the significant drawings acquired by that date; only a few of the most important have been included here. Although no prints have been chosen for inclusion, mention should be made of the Institute's rich collection, which ranges from major works by Dürer to a wealth of late nineteenth-century lithographs by such artists as Toulouse-Lautrec, Bonnard, and Vuillard. Porcelain and the other decorative arts are not represented either.

In recording the facts about an object, the date it was acquired by Mr. Clark is indicated after his initials, R. S. C., and in the dimensions, height precedes width.

Many people helped bring this book to completion; they all deserve my gratitude. The following contributed to or wrote portions of one or more essays: Linda André,

Alan Birnholz, David Cass, Susan Peters, Christine Podmaniczky, Sheryl Reiss, Beth Carver Wees, Robin Fredericks Whitten, and John Wisdom. Eileen Casey Jachym's original research on the meaning of *Children with a Cat* by Dirck Hals has been incorporated into that essay. Particular thanks must go to George Heard Hamilton, who initiated the idea of this book while he was Director of the Institute and has been most helpful with advice and suggestions as it proceeded. Much appreciated editorial help has been supplied by Mary Jo Carpenter, Virginia Riorden, Beth Carver Wees, David Cass, David Brooke, and Martha Asher. Delia Marshall took on the thankless job of typing the manuscript and attending to many details, and Shawnee Baldwin and Sherry Wobus assisted in many ways. Both Annette Fock and Herbert K. Barnett have been very helpful in making arrangements for printing the color plates. The entire project could not have been realized without the financial support of the National Endowment for the Arts, a Federal agency. Finally, I owe my wife my deepest appreciation for her continued support and encouragement of this project over the years.

J. H. B.

When it was obvious that *Highlights* had to be reprinted, a second edition was decided on instead of a reprint in order to correct a few minor errors in the original text, update several entries based on current research, and expand the introduction slightly. It is appropriate to note that this second edition is being published at a time when the Institute is celebrating its thirtieth anniversary.

Introduction

Robert Sterling Clark (1877-1956) savored a full life made possible by a handsome inheritance. But he was a private person and few knew him well. Behind the sobriquet of Mr. Anonymous, which we assume he enjoyed, was a man with several consuming interests: a love of horses, a fascination with the art world and collecting, and an overriding respect for quality and the good life.

Mr. Clark was born in New York City on June 25, 1877, the son of Alfred Corning and Elizabeth Scriven Clark. He was one of four grandsons of Edward Clark, partner of Isaac Singer who invented the Singer sewing machine. In 1899 he graduated as a civil engineer from Yale's Sheffield Scientific School and entered the Army, serving for six years primarily in the Far East. Shortly thereafter he began making plans to explore and map a remote area of northern China. Under his leadership the expedition of thirty-six men carried out zoological and ethnological research, the results of which he published, with a collaborator, in 1912 as *Through Shên-Kan: The Account of the Clark Expedition in North China, 1908-9.*

Although Mr. Clark had inherited several paintings from his family, it was not until 1912, at the age of thirty-five, that he purchased his first works of art. The following year he and his older brother Stephen, who also became a prominent collector, went on an art-buying trip through Europe, and in Florence Robert purchased the Portrait of a Lady (Number 3). He continued to buy art until 1955, but there is no easily definable pattern to his collecting. Initially his attention was drawn to the old masters, particularly to Italian, Dutch, and Flemish painters. The bulk of his collection, however, consists of French nineteenth-century pictures, acquired in quantity during the 1930s and early '40s. His first Renoir, signifying the start of a lasting fascination with that artist, was purchased in 1916; his last one, his thirty-seventh by that master, was bought in 1951.

Mr. Clark returned to the Army during the First World War and served as a high-ranking liaison officer in Paris. He married his French wife Francine in 1919, and together they enjoyed participating in the art scene and visiting their favorite dealers, M. Knoedler and Durand-Ruel, from whom almost three-quarters of the painting collection was acquired. The Clarks relied on little outside advice; they bought art for their own pleasure. Mr. Clark's other major interest was in horses; his chestnut colt Never Say Die thrilled him by winning the Epsom Derby in 1954.

After the Second World War Mr. Clark faced a problem he had pondered since his early years as a collector: what to do with his holdings, which had grown to include not only paintings but also sculpture, porcelains, prints, silver, and drawings from the fifteenth to the nineteenth century. He decided he did not want his collections housed in New York City, and in 1950 he selected Williamstown because of the natural beauty of the area and the presence of Williams College, with which his family had had a long association. His grandfather had graduated from the college in 1831, and both his father and grandfather had been Trustees. Clark Hall, which houses the geology department, was a gift of the family.

Construction of the Institute began in 1953, and it was opened to the public on May 17, 1955, just a year and a half before Mr. Clark died. Mrs. Clark served as president until her own death in 1960. Since then the Institute has continued to acquire important works of art by purchase, gift, and bequest; several of these acquisitions are included here (Numbers 1, 6, 11, 28, and 37). These additions are within the general scope established by the Clarks and serve to enhance the basic collection, providing it with more depth and diversity. Several important acquisitions in silver and numerous significant additions to the holdings in prints and drawings also reflect growth in these areas.

The physical plant, initially a single, neoclassical marble structure designed by Daniel Perry, has been expanded to include a service building (1964), and a large addition (designed by Pietro Belluschi and The Architects Collaborative) has served as the principal entrance since 1973. The Institute has also grown to incorporate several other ancillary organizations and functions. Besides serving as a cooperating institution with Williams College in offering a graduate program in art history (since 1972), the Institute also houses RILA, an art abstracting and indexing service (since 1972), and the Wiliamstown Regional Art Conservation Laboratory (since 1977). In 1950 when Mr. Clark selected the name for his nascent institution to be built in Williamstown, he could have easily called it "Museum" or "Collection." Instead, he decided on "Institute." Was it foresight that prompted his choice? We don't know, but certainly time has confirmed his wisdom.

HIGHLIGHTS

Virgin and Child with Saints Francis, Andrew, Paul, Peter, Stephen, and Louis of Toulouse

Ugolino di Nerio (Ugolino da Siena) Italian, fl. 1317-1327

Of the works of Ugolino da Siena, few remain for us to admire. For instance, one of his most important commissions, the high altarpiece he painted for the church of Santa Croce in Florence, is now dismembered, scattered, and partly lost. The Institute's altarpiece, developed for a Franciscan church, is remarkable not only for its quality, but also because it is one of the earliest known polyptychs to have come down to us in a relatively good state of preservation.

The focus of the composition is the Madonna holding the Child, surmounted by Christ the Redeemer. A retinue of saints flanks her, all identified by their Latin names and their traditional attributes. Nearest to Mary are the apostles Paul with his sword and Peter with his key; next are Andrew and Stephen, the latter in his colorful costume as the first Christian deacon; on the extreme left is Saint Francis (1182-1226); and on the far right is Saint Louis (1273-1297), dressed to recall his position as Bishop of Toulouse. In the triangular panels above, Old Testament prophets display the traditional scrolls predicting the coming of Christ. In the spandrels are small angels, motifs which seem to have their origin in the work of Duccio, Ugolino's master.

The early fourteenth century was a period of transition. The rigid traditions of the Byzantine Empire are continued in this altarpiece in such details as the golden background, the unswerving frontality of the figures, the elongated heads and long, bony fingers, and the didactic symbolism. But the first signs of the Renaissance are apparent: the gentle gracefulness in the Virgin's pose as she covers her baby's shoulders with her shawl, and the rich variety of poses among the angels. The pointed triangular pinnacles along the top suggest recent Gothic influence from the north, while the large, rounded arches recall the older Romanesque style. The entire altarpiece suggests the inside of a church with a central nave flanked by side aisles.

Ugolino used the traditional and durable technique of egg tempera, which dries rapidly and is difficult to manipulate. Pigments obtained from crushed minerals or ground earth were mixed with egg as a binder. The greenish tinge now visible in some skin tones is underpaint not originally intended to show.

Virgin and Child with Saints Francis, Andrew, Paul, Peter,
Stephen, and Louis of Toulouse
Tempera on panel, 126¼ x 58½ inches
(No. 1962.148. Purchased 1962.)

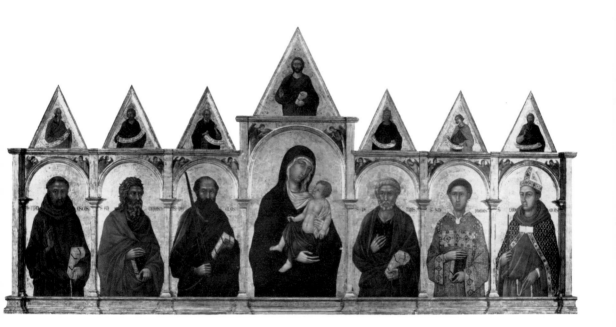

Virgin and Child Enthroned with Four Angels
Piero della Francesca Italian, c. 1420-1492

Seemingly rooted in the complexities of Renaissance science and philosophy, the Virgin sits on a throne offering her Son, in a grand and dignified gesture, a rose, symbol of martyrdom. Four columnar angels are arranged symmetrically, their unobtrusive wings important in the delicate balance of color. Piero composed his pictures with mathematical exactitude, carefully calculating the placement of figures and objects. For example, Mary's head just touches the lower edge of the entablature, and, although she is centered in the overall composition, the Christ Child, doctrinal focus of interest, is placed in the middle of a frame defined by two of the fluted orders. He is surrounded by strong, dominant colors for further emphasis.

Born in Borgo San Sepolcro, Piero later worked in Florence with some of the leading artists of his day and studied and wrote on the new science of perspective. He became a court artist for the Duke of Urbino, and it is possible that the elegant Corinthian columns and the richly carved entablature in this painting derive from certain designs he proposed for the ducal palace there.

Piero's colors are blond and fresh, suggesting, as one scholar has remarked, early morning sunshine. His use of light is sensitive and subtle as it defines the forms. Note the white face of the upper step to the throne where the shadow falls so delicately into the shallow carving of the rosettes.

Because of the unemotional quality of the faces, some critics have felt that Piero was not interested in his people as human beings, treating them as three-dimensional objects akin to his exquisite architecture. But the longer one studies this painting, the less one is satisfied with this explanation. There is something in these faces of emotion, not absorbed into the living personality, but experienced and eternalized, as it were, for serene contemplation. It is perhaps this lofty, untouchable calm which speaks so profoundly to the spectator.

Virgin and Child Enthroned with Four Angels
Oil and tempera on panel, 42⁷⁄₁₆ x 30⁷⁄₈ inches
(No. 948. R.S.C. 1914.)

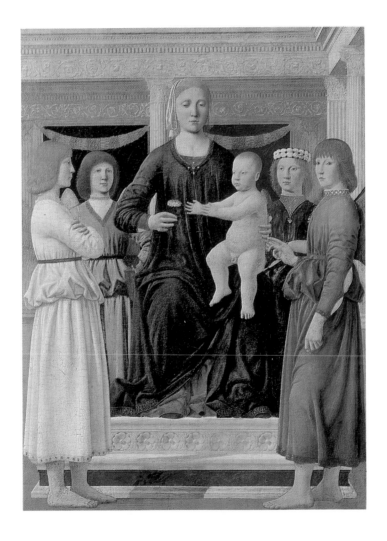

Portrait of a Lady
Domenico Ghirlandaio Italian, 1449-1494

Mr. Clark was thirty-five years old in 1912 when he made his first art purchases. The next year, accompanied by his brother Stephen, he went on a buying trip to Europe with George Grey Barnard, a noted sculptor, and this sensitive Florentine portrait was one of his acquisitions. Sometime in its prior history the painting had been altered to include a crown, halo, and spiked wheel, attributes of St. Catherine of Alexandria, but these had been removed before the painting was purchased by Mr. Clark.

Dressed in a red gown and wearing a distinctive necklace with three pearls, the woman holds an orange blossom in her right hand. This symbolic flower may indicate that the picture served as an engagement portrait. The young lady is seen behind a parapet, suggesting the influence of Flemish art. The precision of draftsmanship and emphasis on linear motifs establish crisp patterns of flowing curves, noticeable in the strands of hair cascading down to frame the sitter's face, in the serpentine roads and rivers of the landscape, and even in the hard outlines of the costume. A distant road at the right picks up the linear rhythms in the design of the dress on the left shoulder and connects them in a graceful curve.

The young woman has sometimes been identified as Giovanna degli Albizzi because of a certain similarity to several profile portraits of her. If this is she, this picture would then have been painted before her wedding in 1486 to Lorenzo Tornabuoni, son of the wealthy merchant Giovanni Tornabuoni. Giovanna died in childbirth, probably in 1488.

Portrait of a Lady
Tempera on panel, 22$\frac{1}{16}$ x 14$\frac{13}{16}$ inches
(No. 938. R.S.C. 1913.)

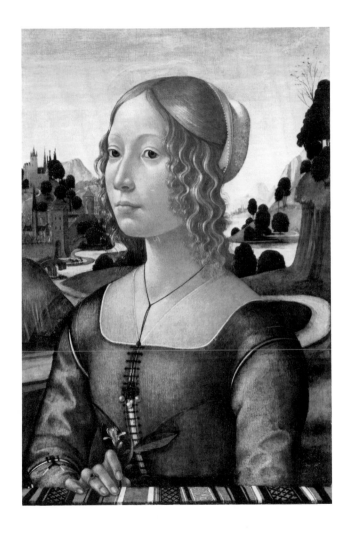

The Canon Gilles Joye
Hans Memling Netherlandish, c. 1430-1494

The identity of this grave-faced man with heavy eyes and a suggestion of a double chin was uncertain for years. The distinguished scholar Max J. Friedländer included this panel in his 1928 catalogue of original works by the Flemish master Hans Memling, but the sitter was identified only as "A Man Praying." The inscription on the frame, which has survived intact, gives the year (1472) and the age (47) of the sitter. The coat of arms, which appears both on the man's ring and on the frame, is a red chevron between three gold billets on white. With the use of this and other evidence, the sitter has been identified as Gilles Joye, an important prelate serving in both Tournai and Cleves. He was installed as a canon in 1463 at Saint Donatien in Bruges and also served as a musician and composer at the Burgundian court of Philip the Good and Charles the Bold, first as *clerc* and then as *chapelain*. At least four of his compositions have survived. After 1468 ill health forced him into retirement, and he died in 1483.

With infinite patience and tiny brushstrokes, Memling records such details as bony knuckles, wrinkles, and even separate hairs. Using the newly discovered oil technique, he captures subtle tonal gradations in Joye's face, as in the slightly hollow left cheek and the highlight on the large, angular nose. The warm and luminous flesh tones are particularly effective against the deep blue background.

Although Memling enjoyed an international reputation, he spent his life quietly in Bruges, which by then had reached the height of its prosperity. His art was calm and unruffled, full of gentle piety. He painted several examples of the diptych (two-panelled altarpiece) showing a person praying to a Madonna and Child; this portrait may originally have constituted half of such a composition.

The Canon Gilles Joye, 1472
Tempera and oil on panel, 12⅜ x 8¾ inches
Dated: 1472
(No. 943. R.S.C. 1919.)

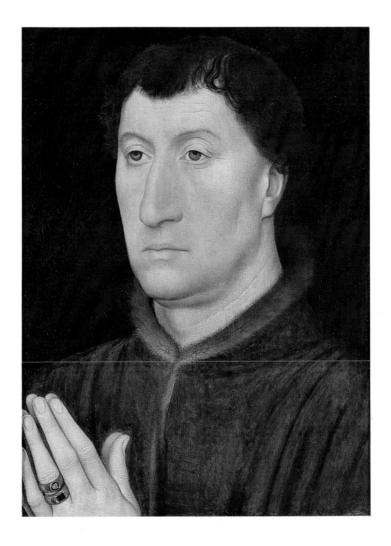

Sketches of Animals and Landscapes
Albrecht Dürer German, 1471-1528

The young Dürer, who received his early training in his father's goldsmith shop, grew up in a time and place which considered the artist to be primarily a craftsman. In 1494 when Dürer traveled from Germany, still bound by Gothic tradition, to Italy, the new world of the Renaissance was all around him. The belief of artists that the aesthetic and scientific theory of art was as important as the development of an artist's technique fascinated the perceptive young man, and from then on Dürer showed a predominant interest in the theoretical aspects of art. His treatises, which almost rival in achievement those of his famous contemporary Leonardo da Vinci, express an interest in understanding the mechanics of living organisms. Our sheet of sketches illustrates brilliantly the artist's skill as an acute observer and transcriber of the natural world.

In 1520-21 Dürer visited the Netherlands to meet the Emperor Charles V, the successor to the artist's former patron Maximilian I, and to petition for the continuation of his pension. During this journey he visited the zoological garden at Brussels, an occasion which undoubtedly provided him with the subjects for the sketches here. Besides two landscapes, a lynx, a lion, two lionesses, a chamois, and a dog-faced baboon are pictured with considerable accuracy. The washes of rose, blue, and gray used in the drawing of the ape are particularly delicate; in several areas they actually take the place of contour lines and complete the form of the animal.

Because each beast is viewed from a different level and distance, it is obvious that Dürer did not intend them to form a unified compositional whole. Only the lynx is related to one of the landscapes, probably drawn so as to include it after the animal had already been conceived as an independent study. Squatting imperiously in the path leading across a bridge to a distant castle, he becomes, like a lion from an ancient Babylonian gate, a symbolic guardian and protector of the town. The architecture of the charming landscape sketches resembles that of contemporary northern Italy. The building and bridge of the upper landscape also appear in an etching of 1545 by Augustin Hirschvogel but seen from a different vantage point, and so in all probability the sketch was based on an actual scene, still to be identified.

Sketches of Animals and Landscapes, 1521
Pen and black ink; blue, gray, and rose wash, 10 7/16 x 15 5/8 inches
Dated and monogrammed: 1521 / *A* over small *D*
(No. 1848. R.S.C. 1946.)

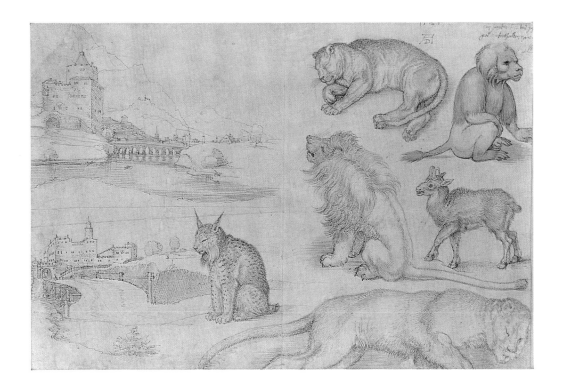

Portrait of a Gentleman
Jan Gossaert, called Mabuse Netherlandish, c. 1472-c. 1533

All we know of this well-attired gentleman is his age, thirty-five, inscribed at the upper right in the green background. One identification of him as Count Orthenburg has been rejected as "unconvincing" by Max J. Friedländer. It is clear that he is a man of considerable wealth because of his elaborate costume, which includes under his fur-lined coat a satin doublet slit at the chest and wrists to reveal puffs of a richly embroidered shirt, two small chains, and a pair of fine gloves held in his hands. His hat is set back on his head so that the special decorations on it can be seen and the white feather revealed in full profile. The shield, with its motto in old French, may establish the identity of the sitter; the design represents a page lifting a tower, flanked by two small structures.

Jan Gossaert, called Mabuse because he or his forebears came from Maubeuge, a town now in northern France, accompanied Philip of Burgundy to Italy in 1508/9. After his return, he tended to combine what he had seen of Italian art with the late Gothic style of the north, producing his own personal kind of Mannerism. By comparing this portrait with Memling's earlier likeness of Gilles Joye (Number 4), one can see how Mabuse joined the two traditions. The monumental quality of this portrait, the harmonious relationship of its various elements, and the sense of a real physical presence no doubt derive from Italian influences. The Memling example, in contrast, seems constructed almost in sections: the hands, the robe, the face, and the hair. The northern fondness for meticulous brushwork, smooth surface, and exacting detail is evident in both portraits. Note the precise rendering of eyes, fur, and jewelry, and the delight both artists take in recording different textures.

Mabuse served Philip of Burgundy for fifteen years. After Philip's death in 1524, Mabuse's portrait commissions increased because he had more time available and his reputation as a portraitist was by then considerable. At this time he painted portraits of King Christian II of Denmark and of the King's three children. It has been suggested that our portrait is also a late work. Whatever the date, *Portrait of a Gentleman* exhibits one characteristic distinctive of Mabuse: fingers which are highly animated. As they fondle the pair of gloves, they enliven the picture and provide a focus of movement in this ornate portrait.

Portrait of a Gentleman
Oil on panel transferred to canvas, 25 x 20⅛ inches
(No. 1968.298. Gift of the Executors of Governor Lehman's
Estate and the Edith and Herbert Lehman Foundation, 1968.)

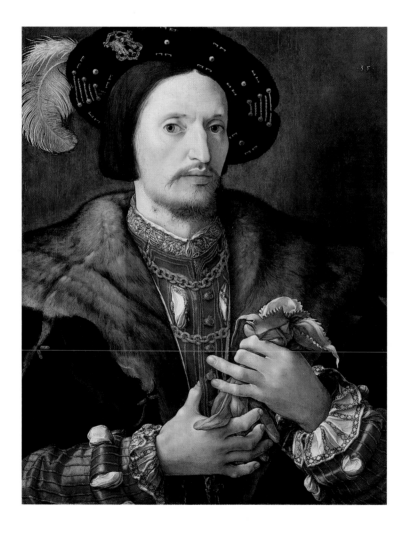

Portrait of Thomas Howard, Earl of Arundel
Peter Paul Rubens Flemish, 1577-1640

In the early seventeenth century Rubens was one of the most famous and sought-after artists in Europe; he was also a trusted and respected diplomat. As ambassador of the Spanish Governors of the Netherlands, Rubens represented his country in many of the great European courts. In 1629, after several other diplomatic missions, he was sent to England, where he was knighted by Charles I. Undoubtedly our study for the portrait of the Earl of Arundel was done at this time.

In this three-quarter-length formal likeness, Thomas Howard, the second Earl of Arundel, is presented in full armor with his helmet outlined beside him. His age is forty-five. He holds the golden baton of the Earl Marshal or Lord High Constable of England, an office conferred on him in 1621 by King James. Better known today as a patron of the arts and collector of antiquities than as a statesman, Thomas Howard received at least two letters from Rubens expressing admiration for his collection of Greek and Roman sculpture.

Energetic and decisive brushstrokes help reinforce the vigorous personality suggested here and reveal Rubens's remarkably free and spontaneous technique. With a single stroke of the pen the artist completes the cuff of the gauntlet; several thick lines suggest a curtain behind. The lines are varied in size for different effects and contrast to the light and dark wash areas which unify this drawing.

The drawing is a study for a portrait in the Isabella Stewart Gardner Museum, Boston. Although Arundel is easily recognized in this sketch, Rubens was not concerned with specific details and modified some features according to his own imagination. The sharp glance to the right, the furrowed brow, and the curled mustache lend the face dramatic force. The blue ribbon of a Knight of the Garter, not in this drawing, was added in the finished portrait, which shows Arundel as a more introspective man. For the details and expression of the face in the final portrait, Rubens made an oil sketch, probably from life, which is in the National Portrait Gallery, London, and which is presumably slightly later than this drawing.

Portrait of Thomas Howard, Earl of Arundel, 1629-30
Brush drawing, 18¼ x 14 inches
(No. 991. R.S.C. after 1926.)

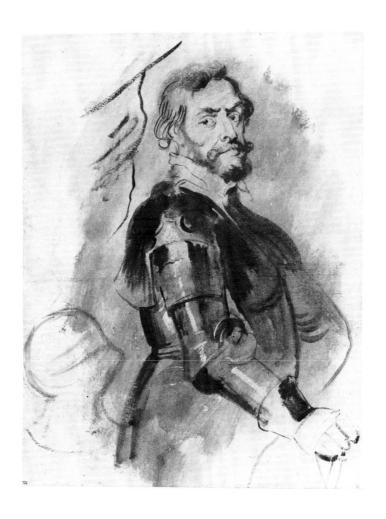

Children with a Cat
Dirck Hals Dutch, 1591-1656

Dirck Hals, younger brother and student of the better known Frans Hals, spent most of his life in Haarlem. In his early years he painted everyday scenes and crowded groups of "merry companies," but about 1630 he began concentrating on paintings of small interiors containing one or two figures. *Children with a Cat* reflects other characteristics of Hals: the smiling and cat-like faces of children and the warm and muted colors which dominate his palette. Here an older girl, wearing a neck ruff, green cap, and tight-fitting gold jacket decorated by tiny floral designs, nestles a kitten in her lap. Instead of playing with the kitten, as we at first think she is doing, the smaller girl teases it with a sharp object pointed directly at the frightened animal.

Dutch genre paintings of this period often had secondary meanings. A complex iconographic analysis based on the study of several popular emblem books has led to the interpretation of this painting and its companion piece, *Children Playing Cards*, also in the Clark collection, as an allegorical reference to woman's role as temptress and subjugator of man. This explains why the older girl is teaching the younger how to taunt and tease.

Children with a Cat is not signed, but its attribution is confirmed by the signature on the other panel. Formerly in the collection of King Leopold I of Belgium, these two paintings were also owned by J. P. Morgan before entering the Clark collection.

Children with a Cat
Oil on panel, 12$\frac{13}{16}$ x 10$\frac{7}{8}$ inches
(No. 756. R.S.C. 1943.)

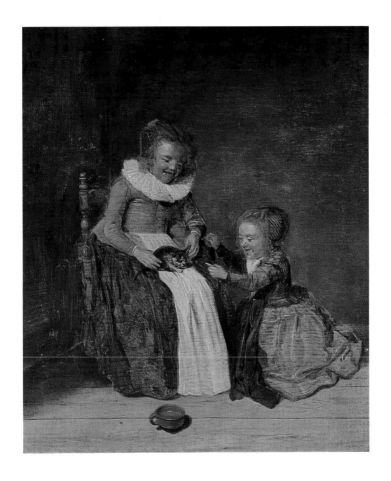

Landscape with Bridge, Cattle, and Figures
Jacob van Ruisdael Dutch, 1628/29-1682

Jacob van Ruisdael, about whom we know very little beyond the fact that he moved to Amsterdam in 1656, was a member of the younger generation of Dutch landscapists who aspired to a style of more grandeur than that of the first half of the seventeenth century. Many of the new directions are visible in this landscape: the juxtaposition of rich, warm colors, like browns and greens, against the cool tones of the sky; the play of light against dark, both along the road in the foreground and back into space carved by the stream; and the balance of static and dynamic forces. In the left center is a dead tree, isolated and silhouetted against the sky. Its sinuous branches make it seem alive, as if it were still struggling heroically to grow.

Goethe first observed that a sense of melancholy pervades many of Ruisdael's works. It is felt here, too, but it is difficult to explain. The inclusion of several dead trees in a scene of fullness and bloom is a factor, as is the sense of isolation created by the lone figure in red on the road at the left. Melancholy is also evoked by a feeling of nature's monumentality contrasted to man's insignificance, suggested by the lofty cluster of oaks rising over the tiny, spot-lit figures on the rickety bridge.

In the abundance of this scene, one could almost forget to admire Ruisdael's varied technique. Small specks of paint describe foliage, and larger, thicker dabs of color stress the rough surfaces of the foreground rocks and distant cliffs. The picture bears Ruisdael's monogram "JR" in the lower right, but, as was typical of many Dutch seventeenth-century landscapes, the figures were not painted by the master himself.

Landscape with Bridge, Cattle, and Figures
Oil on canvas, 37⅝ x 51¹/₁₆ inches
Initialed: JR
(No. 29. R.S.C. 1922.)

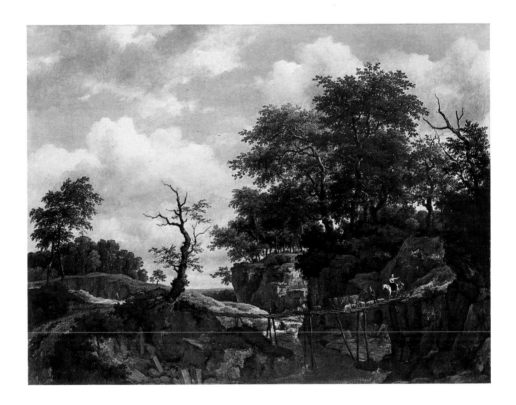

Landscape with the Voyage of Jacob
Claude Lorrain French, 1600-1682

Claude Lorrain was a Frenchman, born not far south of Nancy into a family of pastry cooks. He went to Rome as a young man and found employment with a landscape painter, settling there permanently in 1627. He took particular pleasure in the golden light of the Italian campagna, the picturesque ruins, and the rolling hills and winding streams. Often he would go into the country to make sketches and return to his studio to compose idyllic "classical" landscapes using ideas from his sketches. His work appealed to many important patrons, and he acquired an extensive reputation as a landscape painter.

The seventeenth century was a time of increasing political and religious upheaval and persecution, but these troubled currents seem to have passed Claude by. This landscape is still and quiet; golden light emanates from the distant horizon, dissolving forms. Claude used this formula often. Also typical of this artist is the slow recession from dark foreground into light background, the underplayed meandering diagonals, and the occult balance of large buildings on one side against a tree or other dark shape on the other. The geometric ordering of the composition is also characteristic; for example, the vertical tower bisects the space between the central trees and the left edge. A deep but logical space is created by establishing foreground, middle ground, and background planes which are made to merge gradually. The insignificance of the figures and animals typifies Claude's later work.

A drawing for this painting, inscribed in Italian to the Abbé Chevallier, dated Rome, 1677, and signed "Claudio Gillée," is in the Devonshire Collection, Chatsworth.

Landscape with the Voyage of Jacob, 1677

Oil on canvas, 28 x 37 $\frac{7}{16}$ inches
Signed and dated: CLAUD [IO IVF?] / ROMA 1677
(No. 42. R.S.C. 1918.)

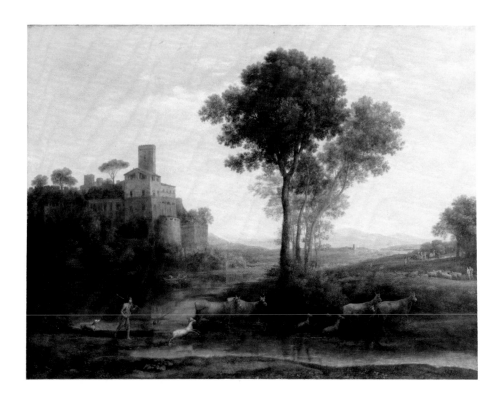

Portrait of a Man (The Warrior)
Jean-Honoré Fragonard French, 1732-1806

It was the eighteenth century, the Age of Enlightenment, and France was the center of the intellectual world. Diderot published his *Encyclopédie*; Rousseau revolutionized political thought with his *Contrat Social* and the novel with *La Nouvelle Héloïse*. Medicine, optics, archaeology, physics, and chemistry made their greatest advances since Aristotle. But the eighteenth century had also to admit to a less serious and more whimsical side: the inviting and fanciful dream world visualized in the paintings of Watteau and continued in the works of Boucher and his pupil Fragonard.

Fragonard was highly successful until changing tastes and political upheavals caused him to fall from favor. In the late 1760s he produced a series of fourteen *Portraits of Fantasy*. These were all painted rapidly; in fact we know from contemporary records that two of them were completed each in one hour's time. They are seen from slightly below, suggesting that they may have been intended, perhaps in pairs, as over-doors. Although some of the portraits have been tentatively identified, *The Warrior* has not.

The most impressive aspect of this painting is the brilliance of the artist's technique. The rich paint, applied with speed and control, builds volumes by sharp angles and sure strokes: a dash of white here, a slash of yellow there. The large square patches which model the end of the nose and fingers are examples. Strong colors—maroons, pinks, and whites—are placed side by side in the face without transition; small, blue-gray strokes dashed on the forehead and around the eye and mouth emphasize them.

Placed behind a parapet, the warrior remains remote from us. His elaborate, seventeenth-century costume, with its large neck ruff, dramatically slashed sleeve, and red cape rippling in what has been called an "heroic wind," strikes a note of fantasy which contrasts with his forceful physical presence and dynamic pose.

Portrait of a Man (The Warrior)
Oil on canvas, 32$\frac{1}{16}$ x 25$\frac{3}{8}$ inches
(No. 1964.8. Purchased 1964.)

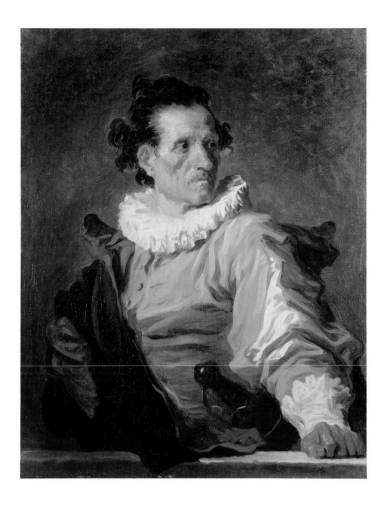

Miss Linley and Her Brother
Thomas Gainsborough British, 1727-1788

Elizabeth Linley (1754-1792) was widely admired as a concert singer who captured audiences with her beautiful face and clear voice. She began singing in public at the age of twelve, and by the time she was nineteen she had captivated London with her performances in oratorios at Drury Lane. One of her many romantic adventures supplied Samuel Foote with the subject for his play "The Maid of Bath." In 1772 she married the noted playwright and statesman Richard Brinsley Sheridan.

Elizabeth appears here at the age of fourteen with her twelve-year-old brother Thomas, a young violinist whom Mozart praised. Their father was a prominent composer and professor of music in fashionable Bath and became a close friend of Gainsborough, who enjoyed fine music and who lived from 1766 to 1774 in the same town. In pale, creamy tones Gainsborough has portrayed Elizabeth gazing into the distance while her undefined hands play idly with her dress. In contrast to her, Thomas, who leans gently against her shoulder, has a ruddy complexion and large eyes which engage the viewer directly. As a further contrast, the red in Thomas's jacket is set off against the delicate blue and silver of his sister's sleeve.

This charming double portrait is also a "fancy picture," a type of painting introduced into England from France not long before. Elizabeth and her brother are dressed in rustic costumes and placed in a pastoral setting as inhabitants of a poetic and upper-class Arcadia, and their somewhat wistful expressions bear this out. At one time this painting was entitled *A Beggar Boy and Girl*.

Miss Linley and Her Brother, c. 1768
Oil on canvas, 27½ x 24½ inches
(No. 955. R.S.C. 1943.)

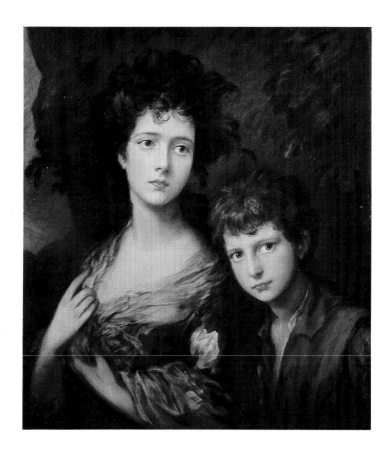

Rockets and Blue Lights
Joseph Mallord William Turner British, 1775-1851

Exploding in the distance beyond the beach's reflections and the crashing surf is a white burst of rockets, framed by the glow of blue lights which signal danger. Two steamers, lost from sight but sending their thick smoke swirling up into the sky, are being warned of shoals. *Rockets and Blue Lights*, like many other late Turner paintings, deals with the elemental forces of nature, "the mysteries of the vastest scenes of earth," as Turner's brilliant advocate John Ruskin wrote. A storm has passed; waves pound the shore. Man, insignificant and helpless, is here a witness; a quiet group of spectators, one holding a spyglass, watches from the wet beach.

The essential meaning of this painting, however, is not conveyed by specific details. When Turner exhibited this painting at the Royal Academy in 1840, he entitled it *Rockets and Blue Lights (Close at Hand) to Warn Steam-Boats of Shoal-Water*. Yet the glowing colors, the suggestive shapes, and the swirling forms developed around diagonals all tell of excitement and danger far better than any individual detail. Turner's appeal is to the emotions; like all romantics he possessed a vital and creative imagination, that power Coleridge claimed was distinct from and far superior to reason.

By 1840, the year Turner met Ruskin, the sixty-five-year-old artist was generally regarded by his contemporaries as an eccentric, not only because of his secretive personal life, but also because of the much-criticized "indistinctiveness" of his art. As a young man he had achieved recognition for his painting and in 1802 at the age of only twenty-seven had been elected a full member of the Royal Academy. But by the 1830s his early, careful rendering of natural objects had given way to a deeper, more highly charged approach which relied to a greater extent on his ability to render light in terms of rich, vibrant colors. His mature oil technique, so effective in capturing the mellowness of the moist, luminous atmosphere in this picture, was built on years of experience with the transparent watercolor medium, tempered by the judicious use of vigorous impasto for accent and texture as, for example, in the breakers. John Constable, a sensitive landscapist one year Turner's junior, marveled at the poetry of his colleague's technical wizardry in a letter of May 12, 1836: "he [Turner] seems to paint with tinted steam, so evanescent, and so airy."

Rockets and Blue Lights, 1840
Oil on canvas, 36$\frac{1}{16}$ x 48$\frac{1}{8}$ inches
(No. 37. R.S.C. 1932.)

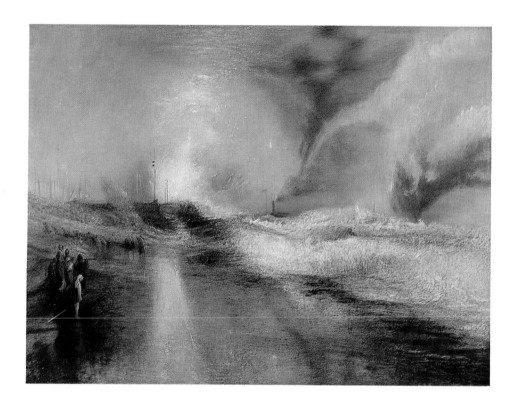

Trumpeter of the Hussars
Théodore Géricault French, 1791-1824

At the beginning of the nineteenth century, the linear neoclassicism of J.-L. David dominated the artistic circles of France. Soon, however, Romanticism arose as a challenge, and Géricault is usually associated with this movement, although his training was in the classical tradition. The *Trumpeter of the Hussars,* an early work in a career of hardly more than twelve years, already suggests elements of Romanticism in the painterly qualities of the technique and the bold color juxtapositions. There is, too, in the heroic theme and monumental concept a sense of nostalgia for the military glories of the Napoleonic era in which Géricault was brought up.

A soldier wearing the uniform of the First Hussars Regiment is mounted on a white charger, his trumpet at his side. Horse and rider are seen from a low vantage point so that they are silhouetted against the glow of orange smoke drifting across the sky. Dramatic lighting from behind increases the drama and mystery by concealing the trumpeter's face in shadow and by creating distinct patterns of illumination on his horse, his uniform, and his equipment. In the distance another soldier flourishes a sabre and rides off to battle. Color, too, is used as an expressive element. To reinforce the mood and impression of conflict, warm tones—reds, oranges and browns—are employed extensively. Against these the cool blues in the trumpeter's uniform and in the sky contrast sharply. Thick, sure brushstrokes delineate the edges of the saddleblanket and model the horse's flank and the soldier's broad shoulders.

Géricault was born in Rouen, but after a few years his family moved to Paris, where he spent most of his life. This painting, completed in 1814 or 1815, is related to a number of similar pictures done at the same time.

Trumpeter of the Hussars, c. 1814
Oil on canvas, 37$\frac{13}{16}$ x 28$\frac{3}{8}$ inches
(No. 959.)

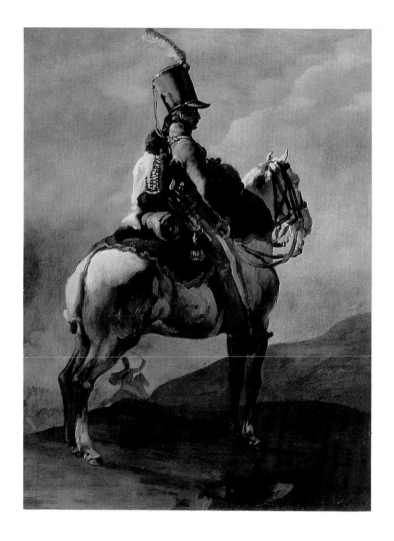

The Castel Sant'Angelo, Rome
Jean-Baptiste-Camille Corot French, 1796-1875

Built as a mausoleum for the Emperor Hadrian in the second century A.D., the Castel Sant'Angelo held special fascination for artists who came to Rome in the eighteenth and nineteenth centuries to record the city's ancient grandeur. Corot, however, was not interested in the castle's historical associations. In this painting it is simply one element in a landscape which gives equal attention to the bridge, the distant dome of St. Peter's, and the fishing boats on the Tiber River. Completed after the artist's second trip to Italy in 1834, when his sensitive treatment of light, form, and distance in terms of tonal values began to emerge, this work illustrates Corot's interest in solid architectural compositions. Several other versions of this painting exist, one in the California Palace of the Legion of Honor in San Francisco.

The beauty of this painting, which is, curiously, signed three times at the lower left, derives from the simplicity of the composition and from the delicate color harmonies, a characteristic which prompted the contemporary poet and critic Baudelaire to term Corot "not a colorist, but a harmonist." In a technique he often used, Corot mixed each of his hues with lead white so that the entire landscape would appear bleached by the same bright Roman sun. He felt free to make minor adjustments in the size or shape of objects to achieve a visual harmony of all parts. Here, for example, he uses the curve as a unifying factor, first in the dome of St. Peter's, then in the arches of the bridge and in their reflections. The two gently curving reflections of the city in the river, although not strictly accurate, continue the theme. Finally, the foreground boats bring many of the curving motifs together into a chorus of rounded shapes. In contrast, numerous verticals anchor the composition.

Corot traveled widely in France and Italy throughout his life recording the landscapes and the people he met, and one finds his portraits and sketches startlingly direct. Although his age was one of artistic ferment and conflicts, he did not choose to become involved, preferring to pursue the subtleties of nature on his own terms. Unpretentious and calm, Corot's landscapes carry no ringing messages and describe no startling events; they seem to be in perfect order, fully realized in a silent moment of time.

The Castel Sant' Angelo, Rome
Oil on canvas, 13⁷⁄₁₆ x 18⁵⁄₁₆ inches
Signed: COROT / COROT / Corot
(No. 555. R.S.C. 1946.)

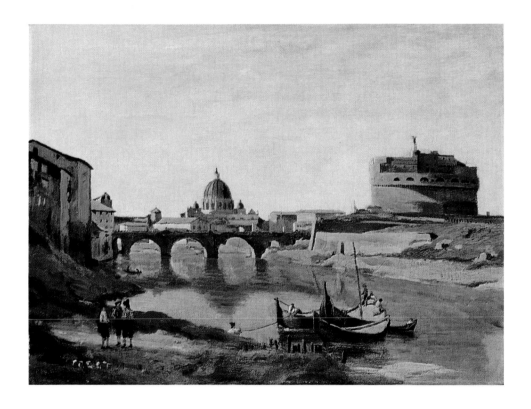

The Print Collectors
Honoré-Victorin Daumier French, 1808-1879

When Daumier was born, Napoleon was at the height of his power, with David his court painter. By the time Daumier died, in the early years of the Third Republic, the Impressionists had already held three exhibitions, and Cézanne was forty years old. Daumier had seen the nineteenth century unfold at a frenetic pace. He had survived three revolutions, the Franco-Prussian War, and the fall of two emperors, two kings, and the Second French Republic. He had spent a short time in prison and had witnessed Haussmann's major redesigning of Paris and the invention of photography. A political and social satirist, he focused on a swiftly changing world of injustice, pretention, and unrest in memorable and sometimes biting cartoons and images which display the sharp incisiveness and perception so well illustrated in this painting, *The Print Collectors*, of the early 1860s.

Reacting in subtly different ways, four men respond to a print held by the man spotlit in the center. He smiles, indicating his pleasure, while another raises his eyebrows. Grouped in pairs—two leaning backward and two forward—they display the concentration of avid collectors, content to be surrounded by loose prints on the table and framed pictures on the walls behind.

Painting with fluidity and economy, Daumier uses a loose brushstroke which defines forms, as in the forearm sleeve in the center. Color is delicately modulated through the earth tones of gray and brown. A red-brown in the wavy hair and dark jacket of the front figure, for example, is played off against the soft blue-grays in the costume of the man in the center. The red of the table top is a subtle and often unnoticed color accent. The entire painting is tightly composed in a triangular format and important details are picked out with lighting from above and behind the figures. This device allows Daumier to bathe all the faces in an atmospheric half-light which helps support the intimate mood. Daumier's art is one of brilliant suggestion, trenchant observation, and technical conciseness and is all the more biting because he drew on real experience for inspiration.

The Print Collectors, c. 1860-63
Oil on panel, 12⁵⁄₁₆ x 15¹⁵⁄₁₆ inches
Signed: h. Daumier
(No. 696. R.S.C. 1925.)

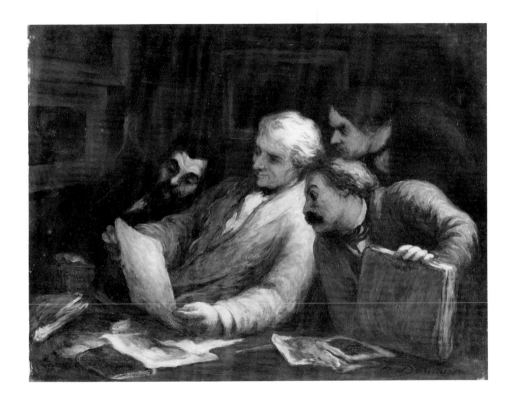

The Knitting Lesson
Jean-François Millet French, 1814-1875

Jean-François Millet is best known as a painter of peasants. Strong in body and spirit, they are hardy folk, but, unlike Bruegel's boisterous types, Millet's farmers have an air of dignity and earnestness about them. They belong to their rustic surroundings and to the earth from which they derive their livelihood.

Of peasant stock himself, Millet believed that "one should see a kind of homely goodness" in the rural life which seemed more "real" to him than the refinements of cosmopolitan society in the throes of the industrial revolution. Millet suffered extreme poverty for years; his lot started to change with the success of *The Winnower* in the Salon of 1848. His work appealed to the popular mind; his homespun sentiments could be easily understood and shared.

In this painting of a young girl being shown how to knit, one feels an overriding sense of grandeur and monumentality, even though the actual size of the canvas is modest and the subject simple. The reasons for this are several. One is the compactness and strength of the central group, composed of two figures drawn together by interlocking curves, which in turn create strong rhythmic patterns and turn the composition continuously inward. Another is the use of generalized shapes to which details are subordinated. Only a few well-chosen items can be seen in this clean and humbly-furnished room: a sewing basket and red pincushion on the windowsill, a pitcher and clean linen on the heavy chest in the rear, and a kitten licking its paw. Millet's technique is restrained and uniform so as not to detract from the central theme, and his colors are muted and subdued, mixed with gray to suggest the soft atmosphere. However, subtle relationships do exist; the little girl, all in blue, is framed by areas of red: the coral of the lady's blouse, the pincushion at the window, and the bright orange-red of the scissors strap on the floor.

The painting exists in several versions, two of which are in Boston's Museum of Fine Arts. It consciously recalls seventeenth-century Dutch genre scenes in which soft light enters a room through a window and illuminates the quiet activity of a few figures. Millet admired the strong simplicity of these earlier paintings, and their intimacy is continued in his work.

The Knitting Lesson, c. 1860
Oil on panel, 16⅝₁₆ x 12⁹₁₆ inches
Signed: J. F. Millet
(No. 533. R.S.C. 1945.)

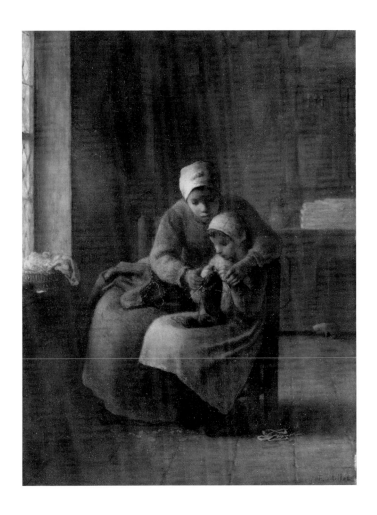

Memories and Regrets
Alfred Stevens Belgian, 1823-1906

Praised by prominent critics, recipient of numerous awards and honors, and friend of many of the most progressive artists of his day—men like Manet, Degas, and Whistler—the Belgian Alfred Stevens spent much of his life in the art capital of the nineteenth century, Paris. There and in Brussels he achieved many successes at the various official exhibitions, and King Leopold II of Belgium purchased several of his works. One of Leopold's commissions was for a series of decorative paintings of the four seasons (1869-76), smaller versions of which form the principal decoration of a gallery at the Clark.

Stevens was interested less in breaking new artistic ground than in refining and perfecting his own style, which is illustrated in his figure studies and elegant interiors, subjects for which he was justly celebrated. In *Memories and Regrets* the elegance and refinements of Parisian society in the late nineteenth century surround a pensive young lady who idly fondles her hair as she daydreams, no doubt about the contents of the note she has just read. The trappings of a comfortable life are evident: a slender parasol and fan, a richly upholstered chair, a fine dressing table decorated with marquetry, and a handsome mirror which offers another view of her face and which reinforces the reflective mood, the subject of the painting.

The composition is carefully developed. The girl is placed on a diagonal running from lower left to upper right, counterbalanced by two groups of impressive still lifes, in the right foreground and left background. Three small areas of robin's-egg blue form a triangle of color accents which also stabilize the composition. All of the details here have been rendered with such care and finesse that one marvels at Stevens's understanding of the paint medium. Note the diaphanous sleeve of the model's dress, the softly lit items on her dressing table, and the sensitive way the curls in her coiffure are recorded. The delicate lighting of her face is especially effective.

Memories and Regrets, c. 1875
Oil on canvas, 24⅛ x 18³⁄₁₆ inches
Signed: A Stevens. (*A* inscribed over the *S*)
(No. 860. R.S.C. 1933.)

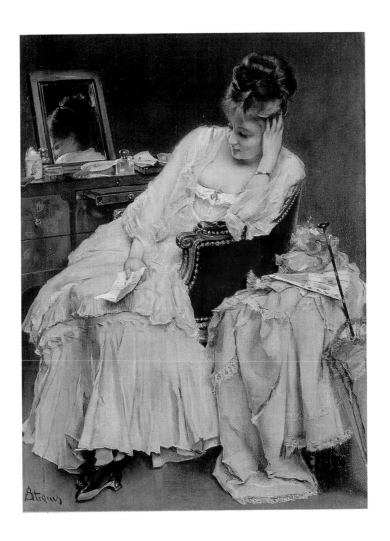

The Snake Charmer
Jean-Léon Gérôme French, 1824-1904

One of the pleasant surprises of the Clark collection is that it contains pictures by both the nineteenth-century French academic artists and their contemporaries, the Impressionists. Even though many of the latter studied under notable academicians, the artistic philosophies of the two schools differed radically. Yet the Clarks collected works by artists in both groups.

The Snake Charmer, painted in the late 1860s, focuses on an old man playing a fipple flute, while a naked boy handles a boa constrictor, a snake found only in the western hemisphere and not generally used for "charming." Watching intently is a group of mercenary soldiers dressed in the different and colorful costumes of their various tribes. Gérôme has made the picture seem natural and informal, but actually he has composed the scene very carefully. The audience is placed in the left half of the painting, and its presence is emphasized by the brilliant reflections of light from the tiles behind. The snake's head and his open basket below mark the center, and the right half contains the two performers against a background of less reflective tiles. The inscriptions from the Koran are in legible Islamic script.

Gérôme's sensitive feeling for color is readily apparent in the subtle touches of reds, greens, tans, and mauves played off against the brilliant aquamarine of the wall. The artist employs a linear approach emphasizing precision of draftsmanship, which results in a painting of almost photographic realism. Note how meticulously even the few missing tiles are depicted. Gérôme's work was often compared to photographs; in fact he was an accomplished photographer, taking many of the pictures which served as models for his paintings.

An exotic subject such as this, very popular in its day, is typical of Gérôme in his middle period and illustrates why he is placed among the "Orientalists," or artists drawing inspiration from the Islamic Near East, then commonly called the "Orient." Between 1854 and his death in 1904, Gérôme made at least seven trips to Egypt and Turkey, bringing back with him hundreds of photographs and "oriental" props: armor, costumes, tiles, rugs, weapons, headdresses, etc. Such trappings as the spear and the shield hanging on the wall and the helmet worn by a spectator in *The Snake Charmer* were part of his collection and appear in other paintings.

The Snake Charmer
Oil on canvas, 33 x 48¹⁄₁₆ inches
Signed: J. L. GEROME.
(No. 51. R.S.C. 1942.)

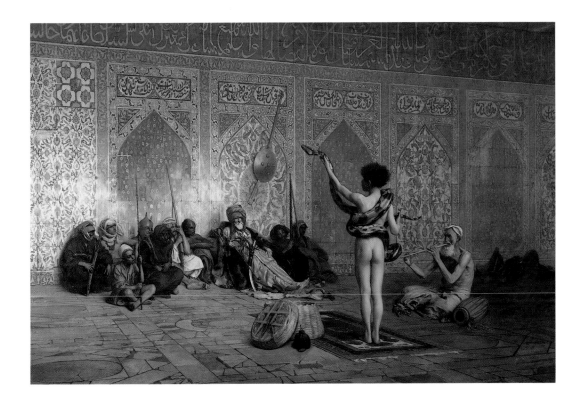

Nymphs and Satyr

Adolphe-William Bouguereau French, 1825-1905

In its own day *Nymphs and Satyr* met the highest standards of academic excellence; it was well received when first shown at the Paris Salon in 1873. One critic remarked that the ladies were rather closer to contemporary life than to classic legend, an aspect of the painting which no doubt delighted its admirers. Its technical mastery, superb finish, and elegant but contrived composition were qualities which made Bouguereau an acclaimed and much honored artist in his time. However, with the acceptance of Impressionism and the movements which followed, Bouguereau's high academic style fell from fashion.

In this painting four nymphs struggle elegantly and effortlessly to persuade a reluctant satyr (half man, half goat) into the water. Three other nymphs in the distant shadows relax. The composition flows gracefully from form to form; each arm, leg, and back relates in a sequence of continuous curves integrating the whole. Every figure is skillfully modeled to appear like a smoothly rounded sculpture, set off against cool, dark foliage. Their similarity of appearance indicates that the cavorting ladies may easily all have been posed by the same model.

After being first owned by a notable New York collector, *Nymphs and Satyr* was sold in 1882 and installed in the bar of the Hoffman House in New York, where it intrigued the public for almost twenty years. It was subsequently relegated to a warehouse until Mr. Clark purchased it in 1942. When it was shown at the Durand-Ruel Galleries in 1943, it generated much comment, both favorable and unfavorable, since it was a prime example of an out-of-favor style. There is evidence that Mr. Clark regarded this acquisition as one of his greatest coups.

Nymphs and Satyr, 1873
Oil on canvas, 102⅜ x 70⅞ inches
Signed and dated: W-BOVGVEREAV-1873
(No. 658. R.S.C. 1942.)

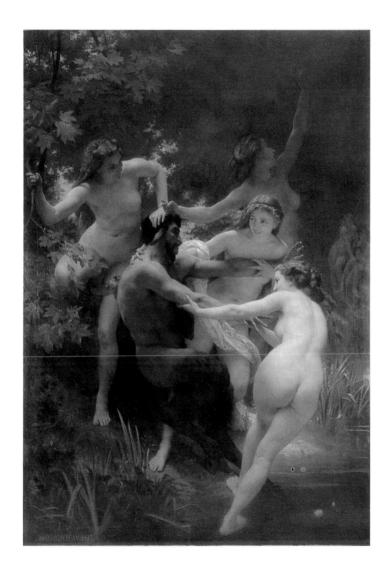

The River Oise near Pontoise
Camille Pissarro French, 1830-1903

The River Oise flows south into the Seine less than twenty miles northwest of Paris. The last major town on the Oise is Pontoise, where Pissarro settled in 1872. In the summer of 1873, when this landscape was executed, Pissarro and his colleagues were developing an approach to painting which a year later was to become known as Impressionism. Most of the familiar elements of that style are here, making this view of factories across the river an immediate and appealing experience. A brisk breeze carries off the smoke and disperses the clouds, and warm sunlight makes the foreground wild flowers seem out of focus.

In a scene so full of freshness, spontaneity, and outdoor atmosphere, Pissarro has nonetheless employed many artistic devices to capture this special moment. By leading us into his painting by way of the easy diagonal of the foreground river bank, he has utilized one of the most traditional compositional methods. The solid architectural forms of the factories, which are clustered together in the left half of the painting, draw attention by their clarity and warm colors. The reflections, which help bridge visually the expanse of the river, are slightly offset and also freely interpreted, forming independent patterns of their own. The lively rhythm of verticals seen against the sky and in the reflections sets up a balance with the quiet horizontals. Touches of red and warm terra cotta tones, hues complementary to the predominant greens, remind one of John Constable's use of similar devices to enrich and enliven his pastoral scenes. In fact Pissarro had recently returned from a visit to London where he had admired both Constable and Turner.

In front of such a vivid and joyous response to nature, it is hard to realize that Pissarro had written that very year to Théodore Duret, a friend and staunch supporter, that he hadn't even one sou left and was working hard to become solvent.

The River Oise near Pontoise, 1873
Oil on canvas, 17¹³⁄₁₆ x 21⅝ inches
Signed and dated: C. Pissarro. 1873
(No. 554. R.S.C. 1945.)

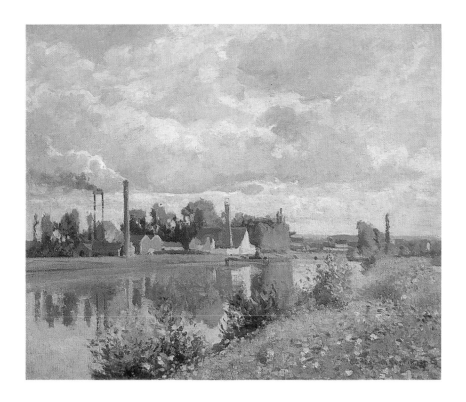

Moss Roses in a Vase
Edouard Manet French, 1832-1883

During the last year or two of his life, Edouard Manet painted some of his freshest and most charming still lifes. This was not a new direction for him; still-life paintings appear throughout his career. Even such a major work as *Olympia* of 1863, later exhibited in the 1865 Salon where it became a *succès de scandale*, included a colorful still life in the bouquet of flowers held by the servant girl.

In this painting moss roses have seemingly been freshly picked and placed in a vase, with little regard for leaves which have dropped off and float in the water and a stray rose which lies at the foot. There is a purposeful carelessness here which differentiates Manet's work from that of other still-life painters of his generation, men like Fantin-Latour and Monticelli. Even though the design looks casual and haphazard, there is artistic control, even to the point of Manet's signature being placed in the lower right where it neatly balances the rose and leaves at the left.

There are several things which make this small painting special. One is the subtle orchestration of color harmonies. The pinks of the roses, framed by dashes of green, stand out against the dark blue background, and the upper half of the vase exhibits a variety of colors—steel blue, gray-green and blue-white. In subtle contrast in the lower section are dabs of red and yellow and strokes of maroon and brown. Another remarkable feature is Manet's bold technique. The pink roses are fashioned out of swirling brushstrokes of thick paint, sometimes seen against bare canvas, effectively suggesting the forms of the flowers and shapes of their petals. The glass vase, at the same time both reflective and transparent, is rendered with long strokes, creating a dappled texture, especially in the upper portion. Manet even records the reflection of a tall window in the neck of the vase.

Moss Roses in a Vase, 1882-83
Oil on canvas, 22 x 13½ inches
Signed: Manet
(No. 556. R.S.C. 1924.)

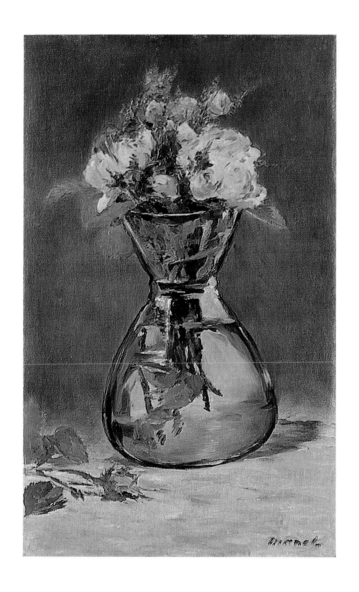

Self-Portrait
Edgar Degas French, 1834-1917

Self portraits can be very revealing. One thinks of the depths of self-examination such painters as Rembrandt and Van Gogh went through in the numerous self portraits they produced throughout their careers. Degas painted himself only a few times, early in his life, and he was not inclined to probe very deeply, but these portraits helped prepare the way for the more incisive likenesses of friends and re-lations which he subsequently produced.

This painting was done when the artist was twenty-three and living in Italy. At the same time he made an etching of himself wearing a soft, wide-brimmed hat similar to the one here; an impression of the etching is also in the Clark collection. Another Degas self portrait of this same period was once owned by Mr. Clark's brother Stephen and is now at The Metropolitan Museum of Art in New York City.

In this cool and quiet portrait Degas looks at us directly so that we feel his pene-trating gaze. His physical features are clearly stated: a long, thin face, tight mouth, and deep eyes. It is rather in the handling of light, the use of the medium, and the control of color that Degas's genius is revealed. A delicate, transparent shadow is cast over the upper part of the face by the hat's broad brim. The left side, furthermore, is sensitively lighted from another direction so that no detail, no contour is hidden in shadow. In terms of technique, the broad brushwork of the clothing contrasts with the precise rendering of the facial features, and the saffron of the cravat adds a subtle color accent, tying together the upper and lower halves of the painting.

Self-Portrait, c. 1857-58
Oil on paper mounted on canvas, 10¼ x 7½ inches
(No. 544. R.S.C. 1948.)

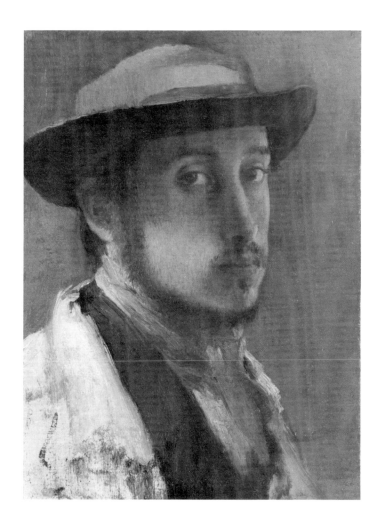

The Entrance of the Masked Dancers
Edgar Degas French, 1834-1917

The title of this colorful pastel refers to the action on stage in the background where masked dancers in blue and yellow capes make their entrance. The two foreground girls are screened from the audience by a flat at the left. However much this scene may at first seem to be unposed and unplanned, Degas's statement, "no art was ever less spontaneous than mine," tells us that there is deliberate thought and careful study in everything he composed. On closer examination, the balance of many opposites is apparent here: one girl in a graceful forward motion looks down and to our left; the other, tugging at her throat band in an awkward gesture, stands still, lifting her head up and to our right. The two share a tight, restrictive space which is in contrast to the brilliantly-lit stage beyond.

There is a gentle interplay of delicate colors here. Soft greens rule the left foreground area, while their complement, pink, is on the right, applied broadly over white. The primary tones—red, yellow, and blue—regulate the quick-changing chromatic rhythms of the background. Degas uses the same acid, lemon-green tint to accent both the outer line of the left ballerina's arm and the other girl's left eye.

Degas became interested in ballet in the late 1860s and began frequenting the rehearsal halls of the Opéra in 1872. The endless studies he did of the young ballet "rats" performing, rehearsing, or simply resting tired bodies reveal his lifelong fascination with movement in all its ramifications. Here every figure is in the process of moving except one, the formally dressed man in a tall black hat observing the scene from the far side.

The Entrance of the Masked Dancers
Pastel on paper, 19⅚₆ x 25½ inches
Signed: Degas
(No. 559. R.S.C. 1927.)

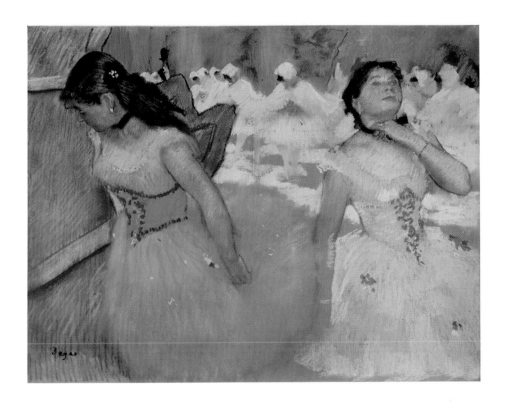

Ballet Dancer Dressed
Edgar Degas French, 1834-1917

The wax version of this dancer was the only sculpture by Degas seen by the public during his lifetime; it was shown in the sixth Impressionist exhibition of 1881. Degas must have started work on this statuette in 1878 when the young model, Marie Van Goethem, was fourteen years old. She no doubt fascinated him with her angular shape and adolescent body. He did a number of preliminary sketches of her, both in her tutu and nude. His final conception was an innovation: a statuette in wax dressed in especially-made garments, in every way a lifelike doll but also a work of art. The skirt was probably below her knees, as that was the style for ballet dress at the time. Degas even devised a horsehair wig. A thin covering of wax united the bodice to the rest of the work, at the same time retaining the texture of the material. The work was finished in minutest detail, even down to the wrinkles in the stockings. Degas was never again to model anything with the care he devoted to this figure; note the slightly shut eyes, raised nose, tightly drawn lips, and high cheek bones. Hands clasped behind her back and pelvis thrown forward to maintain her balance with the dancer's instinctive positioning of the foot, she is both a budding dancer and an impudent little girl.

Born of a wealthy family and fortunate enough to have a private income, Degas was not, like many of his artist friends, dependent upon public acceptance and patronage. This is one of the reasons he was able to remain faithful to the group exhibitions of the Impressionists, and from 1874 to 1886 he participated in seven out of the eight shows. His works were only to be seen there and at the gallery of Durand-Ruel, patient friend and ardent supporter of the Impressionists. When Degas died in 1917, his studio was littered with wax statues of dancers and horses, which were subsequently cast in bronze by A. A. Hébrard. Eight of these bronzes are in the Clark collection. After casting, the young ballet dancer was dressed in a real hair ribbon and a tutu which was short in the style then current.

Ballet Dancer Dressed
Bronze, height: 39 inches
Signed in base: Degas
(No. 45.)

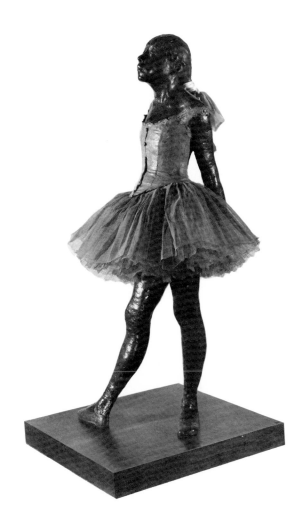

Seascape: Storm
Claude Monet French, 1840-1926

The later 1860s were difficult years for Monet, both financially and artistically. His economic situation was precarious, as his letters tell us, and his painting style was changing rapidly as he explored the *plein air* approach and continued "experimenting with effects of light and color," as he later noted. During these years he spent much time painting along the Normandy coast. *Seascape: Storm* has been dated 1867, during the summer of which Monet lived with an understanding aunt at Sainte-Adresse, just up the coast from Le Havre.

Most young artists are influenced by older masters. Such was the case with Monet, and this painting is a good example of borrowed ideas being used and then shaped to Monet's own creative ends. In 1864 he had met Courbet, and the next year he painted with him and others at Trouville. The influence of the older artist's technique—broad applications of paint and use of a palette knife—appears in this painting in the heavy bow wave pushed up by the sailboat, which runs under a reefed mainsail and a small jib. The palette knife has also been employed in rendering the light gray clouds overhead. Monet also admired the work of Manet, whom he met in 1867. Manet's large, generalized forms and somber colors are suggested here, as well as something of his airless space and flat planes. Monet's own color sense, however, accounts for the bold use of the light green strip on the ocean at the horizon.

Monet composed his painting very carefully around basic horizontal lines, a vertical contrast, and diagonals. The waves in the sea create the dominant horizontal elements, which are played off against the single straight mast, which, with its French flag, soars to the very top of the painting. The light clouds to the left are stacked up, creating a diagonal line which is repeated and reinforced by the angle of the boat's gaff.

Monet later reused this boat and its prominent bow wave as part of a harbor scene at Honfleur, a painting now in the Norton Simon Foundation in California.

Seascape: Storm, c. 1867
Oil on canvas, 19³/₁₆ x 25¹/₂ inches
Signed: Claude Monet
(No. 561. R.S.C. 1950.)

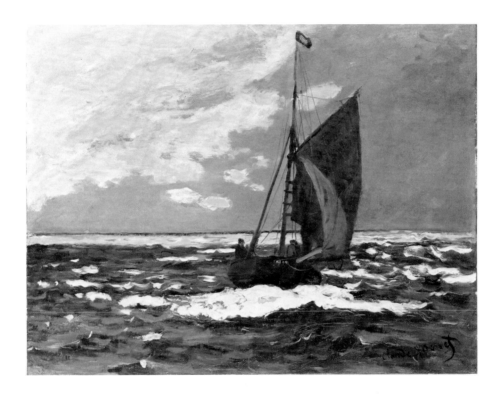

The Cliffs at Etretat
Claude Monet French, 1840-1926

As an Impressionist Monet was drawn to the out-of-doors. He would carry his canvases out into the fields or, as in this case, down to the water's edge where he could see the sparkle of sunlight on water and the reflections of sky and objects. He never tired of recording a variation in the water's color when a cloud passed or when a mist descended.

In the late fall of 1885 Monet returned to the deserted beaches of Etretat, a small town north of Le Havre on the Channel coast, well known among writers and artists for its spectacular rock formations. These vertical cliffs of almost archi-tectural character appear in a number of Monet's canvases, seen from different viewpoints. Monet used a varied brushwork to describe the textures of rough rock, clouds, sand, and wind-ruffled water. At close range the patches of blue, red, yellow, and green suggest nothing more than paint itself. Seen from a distance, however, these color areas are transformed into "impressions" of different ele-ments. The many layers of rock, built up over time, are recorded with horizontal strokes like the water, while the foreground boulder is described with an ener-getic, curving technique.

The weather-beaten "needle" gleams in the sun and reflects its pink and yellow light onto the water below. The reflection of the sunlight, however, begins at the foot of the needle instead of half-way up where the rock is illuminated, illustrating an instance of artistic license. Small sailboats in the distance catch the pink sun-light on their sails, while a tiny rowboat is all but swallowed up in the shadow of the majestic cliffs. Monet's technique has matured and expanded considerably since his early attempts at rendering the sea and its moods (see Number 26).

The Cliffs at Etretat, 1885
Oil on canvas, 25⁹⁄₁₆ x 31¹⁵⁄₁₆ inches
Signed and dated: Claude Monet 85
(No. 528. R.S.C. 1933.)

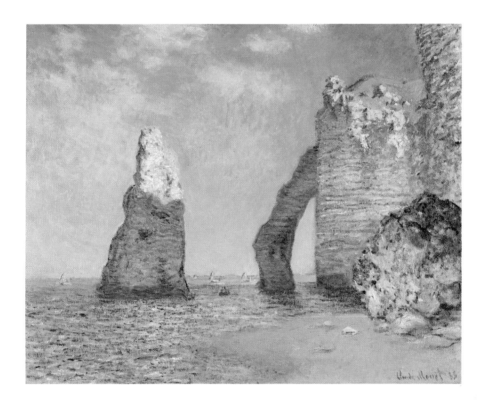

Rouen Cathedral: The Façade in Sunlight
Claude Monet French, 1840-1926

Monet's series of thirty-odd views of Rouen Cathedral has been the subject of much interpretation and controversy among critics and the public since twenty of them were exhibited at Durand-Ruel's gallery in Paris in May, 1895. The series has been criticized as "muffled, obstinate pictures" looking like "melting ice creams" (Kenneth Clark) as well as praised as the "climax of impressionism" (George Heard Hamilton). Pissarro wrote to his son in London after seeing the exhibition that the cathedrals should be seen together as a group and that in its entirety the series had a "superb unity." However, as Monet well knew, the series would inevitably be dispersed, and each painting would need to stand on its own.

At close range this example becomes an intensely tactile experience of heavy impasto; lemon pinks, orange-reds, lavenders, and mauves harmonize in a constantly recurring rhythm of colors. The blue of the sky is repeated, or perhaps we should say reflected, throughout, particularly on the left tower; the soft golden reds and oranges of the main doorway reappear fleetingly in the rose window and above. Creamy pinks punctuate the façade everywhere. The colors do not actually change, of course, but the impression is one of evanescence, of the image dissolving in—or appearing out of—a thick atmosphere of warm, richly-colored light.

When seen from a distance all the separate colors coalesce to suggest a cathedral. The painting may be understood as an artist's personal record of his sensitivity to that ephemeral, midday light which touches the façade with delicate nuances. However, as a single image separated from others in the series, it exists without the sense of continuity and change Monet experienced as he developed the group as a whole during the period 1892-95, both at Rouen and in his studio at Giverny. The viewer is left to supply that sense of the changing moment himself.

Rouen Cathedral: The Façade in Sunlight, 1894
Oil on canvas, 41¹³⁄₁₆ x 29 inches
Signed and dated: Claude Monet 94
(No. 1967.1. Purchased 1967.)

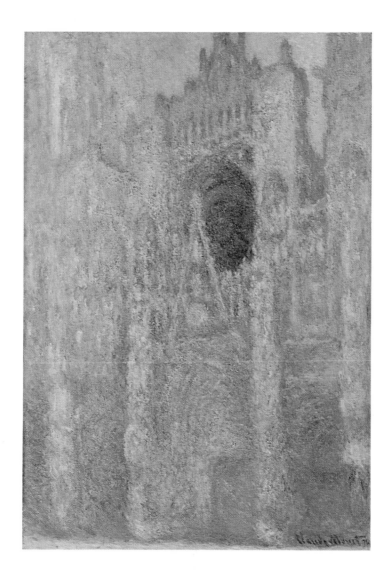

Sleeping Girl with a Cat
Pierre-Auguste Renoir French, 1841-1919

As one of the leaders of the Impressionists, Renoir participated in four of their eight group exhibitions, the first of which was held in 1874. He was active in enlisting the support and interest of other artists and often supervised the hanging arrangements. However, from 1878 to 1881 he stopped exhibiting with his friends and submitted entries, with some success, to the annual Salon, the official, government-sponsored exhibition against which the Impressionists had originally turned in frustration. Renoir claimed he did not want to waste time bearing a grudge against the Salon and maintained that his decision was motivated strictly by business considerations. *Sleeping Girl with a Cat* was one of his two paintings submitted and shown at the Salon of 1880. In 1882 this same work appeared, along with twenty-four other paintings by Renoir, in the seventh Impressionist exhibition, a probable indication that the artistic and philosophical differences between the two camps had already lessened.

In this painting eighteen-year-old Angèle, a Montmartre florist and one of the artist's favorite models, dozes in a scarlet chair in the middle of a large, empty room. Renoir's use of color, with bright blue and red predominating, is one of the most appealing aspects of this picture. The third primary, yellow, appears fleetingly in the many-colored bouquet of flowers pinned to the hat. Under various conditions of light—direct light, reflected light, and shade—Angèle's skin changes tone, allowing a rose tint to dominate the face and a blue to prevail in the neck.

The light which bathes the model would seem to be natural illumination from an overhead window. It blurs and softens outlines as it changes in intensity and reveals subtle chromatic nuances, as in the cat's fur which blends in with the blue dress. As in most Impressionist pictures, light and color are inseparable. Note for instance how the bright red color of the chair is reflected in Angèle's white hat.

Sleeping Girl with a Cat, 1880
Oil on canvas, 47¼ x 36⁵⁄₁₆ inches
Signed and dated: Renoir. 80.
(No. 598. R.S.C. 1926.)

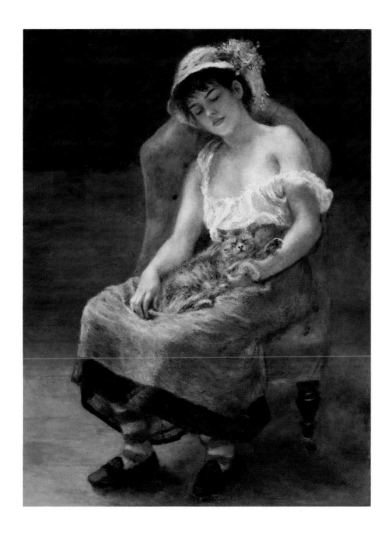

Onions

Pierre-Auguste Renoir French, 1841-1919

In the fall of 1881 Renoir left on a trip to Italy which was to have an important influence on his artistic development (see Number 31). Painting as he travelled, he visited Venice, Rome, and Naples, where he executed *Onions*, as the inscription in the lower left indicates. The Institute owns three other paintings by Renoir done during the same journey.

This picture reportedly was Mr. Clark's favorite; no doubt the lively composition, the free technique, and the warm, high-keyed colors appealed to him. Renoir arranges the bulbous, larger-than-life onions and the two garlic buds in a stable composition which celebrates the twisting curves and rhythms of the vegetables. Note how carefully the relationship of parts is developed. A single onion is on the forward edge of the rumpled cloth, tilting toward the other onions and parallel to two of them.

A vigorous pattern of brushstrokes is used to define the forms of the vegetables and emphasize the textures of their thin, flaky skins. A different rhythm, that of parallel diagonal strokes, is used in the blue-green background. Light reflects from the crisp skins and affords a vivid color accent among the lavenders, pinks, oranges, and mustard hues.

It is sometimes difficult, and even unfair, to analyze a painting in too much detail because the sense for the whole can sometimes become obscured. Renoir realized this and is reported to have said, "Nowadays they want to explain everything, but if they could explain a picture, it wouldn't be art."

Onions, 1881
Oil on canvas, 15⅜ x 23⅞ inches
Signed and dated: Renoir. Naples. 81.
(No. 588. R.S.C. 1922.)

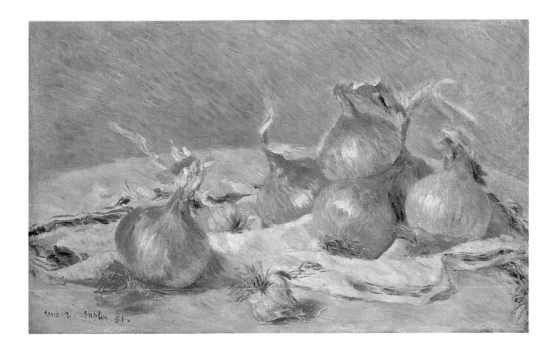

Bather Arranging Her Hair
Pierre-Auguste Renoir French, 1841-1919

Renoir's Italian trip of 1881-82 significantly affected his style of painting. Impressed with the art he had seen in Rome, Naples, and Pompeii, Renoir wrote to a patron in 1882 that he hoped to acquire the "simplicity and grandeur" of the ancient masters. He was dissatisfied and discouraged with his impressionistic style, as he later told his friend Vollard, an art dealer. Renoir felt that in working outdoors he had looked "only for the effects of light," neglecting other concerns. He later recalled, "About 1883 . . . I had gone to the end of 'Impressionism' and was realizing that I no longer knew how to paint or draw. In a word, I was at a dead end." His approach changed, and firmly controlled drawing and sculpturesque modeling replaced the soft, blurred outlines and transient effects of light typical of his earlier style. His new approach culminated in the large *Bathers* of 1887, now in the Philadelphia Museum of Art.

Bather Arranging Her Hair of 1885 illustrates very well the new directions Renoir was exploring at the time. Here a firm line delineates the model, setting her off in relief from the surrounding atmosphere and the softly rendered, slightly out-of-focus background of land, water, and sky. This elegant and precisely-drawn contour is an important part of Renoir's new approach. On the one hand the plastic elements of the body are solidly rendered with clear definitions of volumes through careful drawing and shading, while on the other the use of high-keyed colors and a vigorous free technique (particularly noticeable in the background) suggests Renoir was not discarding his former style completely, although the earlier wide range of colors has been reduced to pearly, pastel tints, reminiscent of the frescoes he had admired in Italy. In this subtle blend of old and new the model's deep red-brown hair is an accent within a scheme of pale colors.

Renoir's new tendency toward solidity and structure also reflects the influence of Cézanne, whom he visited in the south of France early in 1882. The background of this work resembles the bay of L'Estaque, which both artists painted. Cézanne's influence is apparent in Renoir's brushstrokes and in his concept of the bather as a timeless and monumental creature.

Bather Arranging Her Hair, 1885
Oil on canvas, 36³⁄₁₆ x 28¾ inches
Signed and dated: Renoir 85.
(No. 589. R.S.C. 1937.)

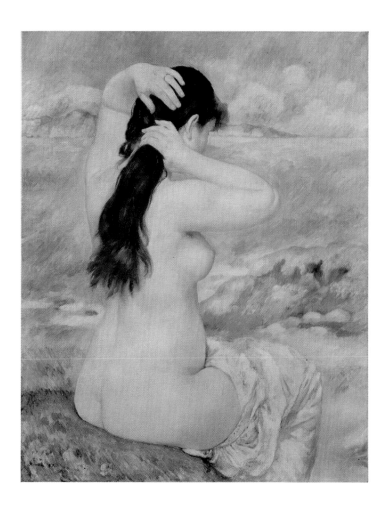

Crossing the Street
Giovanni Boldini Italian, 1845-1931

Among the many foreign-born artists working in Paris during the 1870s were the Spaniard Raimundo Madrazo y Garreta, the Belgian Alfred Stevens, and the Italian Giovanni Boldini; the Clarks collected paintings by each of them. Their elegant pictures reflect the lifestyle of their patrons, the Parisian *haute bourgeoisie*. In the 1870s Boldini, who achieved fame later as a fashionable portraitist, painted small, intimate interior pieces as well as views of the bridges, streets, and squares of Paris, such as *Crossing the Street*. The location is the rue Chauveau-Lagarde, a short steet near the Church of the Madeleine.

This panel depicts an elegantly dressed young lady crossing a cobblestone street. A small dog, a stout woman, and a man in a horse-drawn cart all continue on their way, imparting a feeling of spontaneity to the scene. They have been carefully located on a diagonal leading away from the central figure. The picture is completed on the left by the gentleman in a passing carriage who turns his head to admire the woman. The wrapping of the bouquet, like an arrow, points toward his face.

The young lady is a model who posed for many of Boldini's genre pictures in the early 1870s. It has been suggested that the man in the carriage is the artist himself, but this is doubtful, for, unlike that gentleman, Boldini was fair.

This painting demonstrates considerable sensitivity to color, as in the pink reflections of the flowers in the lady's face and the green highlights on her dress. Certain passages, such as the brightly colored bouquet, are executed with great freedom. Although Boldini was friendly with several of the Impressionists, his use of a loose brushstroke similar to theirs was for a different purpose, to animate the surface.

Crossing the Street, 1875
Oil on panel, 18 1/16 x 14 3/4 inches
Signed and dated: Boldini / 75
(No. 650. R.S.C. 1925.)

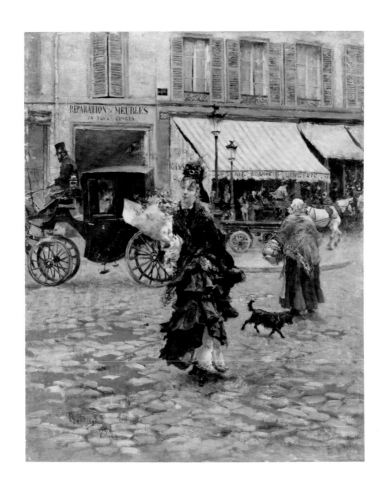

Jane Avril
Henri de Toulouse-Lautrec French, 1864-1901

One cannot think of the late nineteenth-century Parisian dance halls and their stars and clientele without calling to mind images of Yvette Guilbert, La Goulue, and Jane Avril. We see them through Toulouse-Lautrec's penetrating eyes, unforgettable characters in his posters, prints, and paintings. The faces, the costumes, the personalities, the mannerisms of an era are all there.

Jane Avril is seen here with her large cape drawn tightly around her shoulders and her elaborately plumed hat sitting squarely on her head. Slender and pale, she faces us directly with a harsh yellow spotlight flooding one side of her face. Lautrec has captured in her tight, bowstring mouth and long, angular face something of her studied elegance and pensiveness.

The year 1892, when this work was painted, was one of the most productive for Lautrec. His first important lithographs were issued, several successful posters were printed, and many significant paintings were completed. This work was swiftly done on poor quality cardboard, which was favored by Lautrec for its soft color and rich texture. The composition is developed around an arabesque of curves weaving through the work, linking parts and creating interesting shapes. The outlines of both the cape, especially along the trim, and the attached collar delight the eye with their serpentine rhythms of thick and thin lines; the elaborate hat is full of whimsical, curving shapes. In contrast is the irregular vertical rhythm of the thick, blue-green lines of the background.

Jane Avril, one of the celebrated Moulin Rouge dancers whom Lautrec immortalized, was one of the few people who understood this lonely, crippled man and took an honest interest in his work. A friend of numerous artists and writers, she was witty, gracious, and charming and often acted as hostess for Lautrec's studio parties. His lasting tribute was the many posters, paintings, and drawings he produced of her, both on stage and off.

Jane Avril, 1892
Oil on cardboard, mounted on panel, 24⅞ x 16⅝ inches
Initialed: HTL
(No. 566. R.S.C. 1940.)

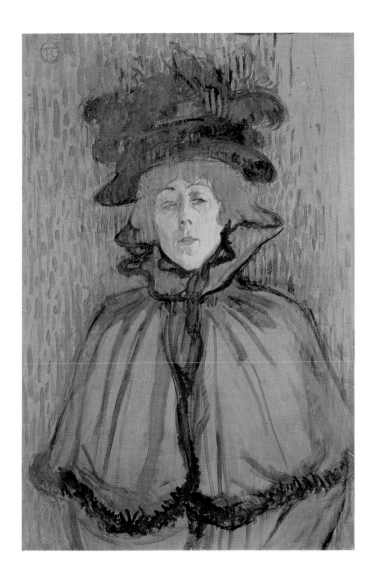

The Bridle Path, White Mountains
Winslow Homer American, 1836-1910

Winslow Homer was a dedicated outdoorsman. Although he worked for a lithographer in Boston for a short time and later as an illustrator in New York, he disliked city life and never considered it worth painting. In the summer he would escape to the country where he could hunt, fish, climb mountains, and fill both his memory and his sketchbooks with scenes he loved.

He spent the summer of 1868 in the White Mountains of New Hampshire, which provide the setting for this painting. A bonneted young woman riding side-saddle descends the Crawford Trail on Mount Washington. Her horse, adorned with a leafy sprig between its ears, picks its way along the rocky trail, as two of the girl's companions round the bend ahead and two others follow at a distance. Trusting to the animal, the girl leaves the reins loose. The distant mountains appear blue under a blanket of summer haze.

This painting is the first of two to record this particular scene. The second, now in the Art Institute of Chicago, was done the following year and shows another mounted figure alongside this young lady and several dismounted riders with their horses. Yet a third variation of this scene, again showing the girl with a companion, appeared as an illustration in *Harper's Weekly* on July 10, 1869. The Clark version, with its simple composition and clear focus, emphasizes the space and freedom of the open mountains.

The year before this was painted Homer spent ten months in France, where the artists who were later to be called the Impressionists were active. Although it is not known how much he was exposed to their ideas, he did bring back a temporarily lightened palette, and his own natural sense of outdoor light and atmosphere was intensified. Here the girl and her horse are sharply outlined in a sparkle of warm sunlight from behind, and a golden reflection from the rocky foreground modifies the color of the white horse.

Homer includes "N.A." after his signature in the lower left, indicating that he was a member of the National Academy of Design, to which he had been elected in 1866.

The Bridle Path, White Mountains, 1868
Oil on canvas, 24⅛ x 38 inches
Signed and dated: HOMER N.A. / -1868-
(No. 2. R.S.C. 1950.)

An October Day
Winslow Homer American, 1836-1910

Always a keen observer and recorder of nature, Homer focused in his later years on water, as his impressive late seascapes at the Clark illustrate. Not only did he respond to its many moods, but he also delighted in its reflective qualities, which he could best study during the trips he made to inland lakes. One such was in the autumn of 1889, when the artist was in the Adirondacks on one of his regular hunting and fishing excursions; during this stay he produced *An October Day*. The trees on the shore, mirrored in the still lake, flame up in bursts of yellow and green, and a bluish haze floats through the woods beyond. A few stands of maples, russet at this time of year, color the hillside. At the left a man in a boat is rowing toward a swimming deer. Although the scene seems innocent enough, it could possibly be related to one method of "hunting" deer in the last century: the "hunter" drove the animal into the water, approached it by boat, and held its head under water until it drowned.

During the 1880s Homer perfected his watercolor technique. His method in recording this scene varies according to what he is depicting. The wake of the deer, for example, is rendered by scratching the paper so that the transparent blue wash, applied thinly to let the white of the paper show through, takes on the mottled texture of disturbed water. The distant mountains are generalized and developed through a technique of soaking and blotting. There are two separate reflections of the deer's antlers, one of which, we must presume, was not intended. Watercolor is a demanding technique; changes are difficult to make.

Using the medium of water itself, Homer has captured here the very essence of that substance, its movement, reflectiveness, and transparency.

An October Day, 1889
Watercolor, 13 ⅞ x 19 ¾ inches
Signed and dated: Winslow Homer 1889
(No. 770. R.S.C. 1947.)

West Point, Prout's Neck
Winslow Homer American, 1836-1910

During Homer's later years when he lived on the ocean in Maine, the sea was a frequent subject for his paintings. It dominates this picture, a view from the west point of Prout's Neck, which is south of Portland. Beyond foreground rocks lies a quiet ocean, undulating under a colorful sunset. In the far distance one can just discern a strip of land where a few early evening lights are visible. The dark, thin shadow on the water is a swell which has just passed. The next wave is starting to pour into the picture at the left, creating that elegant, reverse S-curve of spray, a design motif reminiscent of devices used in Japanese prints, with which Homer was familiar. This detail, painted in very soft colors of blues and light greens, is a vertical accent in a strongly horizontal composition. Its curving shape, however, relates it in a subtle way to other elements: the small tail of a cloud in the upper right, the rhythm of the water in the foreground, and the more jagged outline of the chocolate brown rocks.

Homer finished this picture on December 23, 1900, and wrote about it:

> The picture is painted <u>fifteen minutes</u> after sunset—not one minute before—as up to that minute the clouds over the sun would have their edges lighted with a brilliant glow of color—but now . . . the sun has got beyond their immediate range & <u>they are in shadow</u>. . . . You can see that it took many days of careful observation to get this, (with a high sea & tide just right).

His sense of the moment and attention to lighting effects recall similar concerns of the French Impressionists.

Homer's late paintings focus on the elemental forces of nature and suggest in their sense of loneliness the isolation of the artist himself. Echoing that earlier New Englander Henry David Thoreau at Walden Pond, Homer wrote: "No other man or woman within half a mile. . . . This is the only life in which I am permitted to mind my own business. . . . I am perfectly happy and contended." Paintings such as *West Point, Prout's Neck* seem to reflect this inner peace.

West Point, Prout's Neck, 1900
Oil on canvas, 30$\frac{1}{16}$ x 48$\frac{1}{8}$ inches
Signed and dated: HOMER 1900.
(No. 7. R.S.C. 1941.)

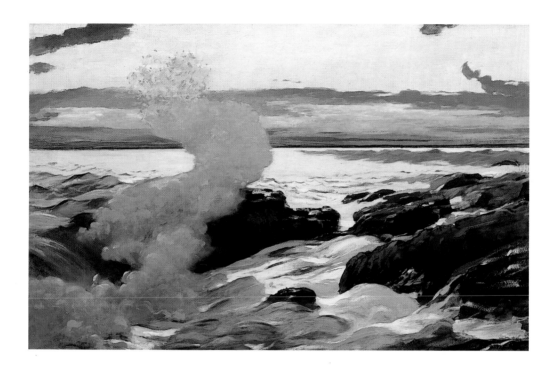

Woman with Baby

Mary Stevenson Cassatt American, 1844-1926

Mary Cassatt's favorite subject by far was the portrait, and her favorite medium was pastel. Never a mother herself, Cassatt captured with special insight the nuances of feeling between mother and child. In this double portrait of an unidentified woman holding her nude daughter, the close relationship is reinforced by the affectionate embrace of the two and the mother's glance at the girl, whose own attention seems to have been caught by something outside the picture.

Woman with Baby, done around 1902, uses a variety of brilliant colors. The vivid orange of the lady's negligée swells up from the bottom of the picture without regard for form or shape. Random blue and green patterns punctuate this orange, and these colors recur with full intensity in the background. A red stripe behind the woman also adds to the vivid coloration.

In 1866 Mary Cassatt, despite parental objections, went to study art in Paris and remained in France for the rest of her life, with only occasional visits home to Philadelphia. When asked to join the Impressionist group in the late 1870s, Cassatt later recalled, "I accepted with joy. . . . I took leave of conventional art. I began to live." She showed with the Impressionists in four of their eight exhibitions, and even the cynical and cantankerous Degas, her mentor, was particularly impressed with the painting she submitted to the last exhibition in 1886. He wrote her, "What drawing; what style!" Because of her wise advice, a great many important Impressionist works are now in the United States.

Woman with Baby, c. 1902
Pastel on gray paper, 28⅜ x 20⅞ inches
Signed: Mary Cassatt
(No. 1968.301. Gift of the Executors of Governor Lehman's
Estate and the Edith and Herbert Lehman Foundation, 1968.)

Portrait of Carolus-Duran

John Singer Sargent American, 1856-1925

The precocious Sargent spent his childhood touring Europe with his family, and he absorbed a great deal on these travels. His mother encouraged him, and by the age of eighteen his talents were sufficiently developed to make formal art training in Paris the next logical step. In 1874 he entered the studio of Carolus-Duran (1838-1917) and in time became the outstanding pupil in a class composed mostly of Britons and Americans. Carolus-Duran had enjoyed a reputation as a brilliant young portraitist ever since his success in the Salon of 1869; the Institute owns a forceful picture by him of his gardener, which shows some of the bravura technique the older artist passed on to Sargent.

In 1878 Carolus-Duran consented to sit for his talented student, and Sargent dedicated this portrait to his "master," as the inscription in the upper right indicates. Into the somber scheme of essentially neutral tones—browns, grays, and tans—Sargent has introduced several bold color accents: dashes of white, a red (the rosette of the Legion of Honor), and a deep blue in the ring on the right hand and on the chair behind. A close study of these areas will indicate how free and effective Sargent's technique was, even at this early stage in his career. Note particularly the broadly painted white cuffs and shirt collar which draw attention to the face and elegant hands. We assume Carolus-Duran was pleased with his portrait's purposeful informality and technical skill; Sargent has also captured something of his teacher's self-assured and debonair manner as revealed in his fashionable dress and spirited pose.

A contemporary letter recounts that this painting attracted considerable attention in the Salon of 1879 (it received an honorable mention) and that some thought the portrait "amazing." The letter goes on to suggest that Sargent would astonish the Paris public some day, a prediction which would have been more accurate if mention had also been made of the London and Boston public as well. Henry James thought enough of this picture to include a mention of it in his book *Picture and Text*, published in 1893.

A drawing for this painting is in the collection of The Art Museum, Princeton University.

Portrait of Carolus-Duran, 1879
Oil on canvas, 46 x 37¹³⁄₁₆ inches
Signed and dated: John S. Sargent. 1879
(No. 14. R.S.C. 1920.)

A Street in Venice
John Singer Sargent American, 1856-1925

Venice has always attracted artists and inspired some of their best work. Turner, Whistler, Renoir, Monet, and so many other nineteenth-century painters responded to its charm and atmosphere. For Sargent as for Whistler, the back alleys and dark interiors were just as alive and intriguing as the more frequently rendered major landmarks. Scenes like this narrow street were done either during Sargent's first visit in 1880, or more probably in the late summer of 1882 when he returned and lived with his cousins. Exhibited in Paris a year later, these personal interpretations of Venice did not appeal to the critic Arthur Baignères who unenthusiastically reviewed the "First Exhibition of the International Society of Painters and Sculptors." He wondered what was so appealing and typically Venetian about obscure squares, dark streets, and sad, serious people. Were not these same things also observable in Paris? He reserved his enthusiasm for Sargent's portraits.

This painting does have its fascination, however. Prominent perspective lines, reinforced by the shape of the bricks in the crumbling wall, accentuate the deep and narrow space. The dimness of the passageway is emphasized by contrast to the intensely-lit buildings beyond. Two figures, alone in an empty street, wear solid black capes which read as flat shapes instead of rounded forms. The lady's subdued russet skirt imparts a subtle coloristic accent to the dominant somber shades of light tans, grays, ochres, and browns—the same dark colors Sargent had admired in Velázquez's paintings which he had studied during a trip to Spain. With a very free application of paint Sargent has created numerous textures; a palette knife is even used to develop the foreground pavement.

A Street in Venice, 1882
Oil on canvas, 27⁹⁄₁₆ x 20⅝ inches
Signed: John S. Sargent / Venise
(No. 575. R.S.C. 1926.)

Dismounted: The Fourth Troopers Moving the Led Horses
Frederic Remington American, 1861-1909

Charging straight at us out of the heat and dust of the Old West come the hard-riding, straight-shooting men who were Frederic Remington's heroes and whose deeds he recorded throughout his career. Remington was an Easterner, born in Canton, New York, and lived much of his later life in New Rochelle. Forced to leave Yale by his father's death, he headed west in 1881. During these early years he worked as a cowboy, store clerk, and scout; tried gold prospecting, real estate, and sheep herding; rode with posses and drank with the cavalry. He travelled the already obsolete West for years, recording the scenes that struck his imagination, because, as he wrote, "The wild riders and the vacant land were about to vanish forever.... I began to try to record some facts around me, and the more I looked, the more the panorama unfolded." His first few years as an artist were difficult ones with little recognition for his illustrations, but by 1887 *Harper's Weekly* was publishing his work regularly, and his oils were being accepted in important exhibitions. From then on his success as a Western artist was assured.

The subject here has been identified as Custer's Seventh Cavalry performing a maneuver preceding the Massacre of 1876 at the Little Big Horn, but a few inaccuracies in uniform have been noted. Remington did not witness the event; he painted this work fourteen years afterwards. What is shown here was a standard cavalry procedure whenever a unit fought dismounted. Every fourth man was deputed to lead three riderless horses out of danger, which in this instance is directly toward the viewer. In the left distance soldiers fire at an unseen enemy. All the excitement of the old Wild West is here: horses gallop and rifles blaze away. Note how Remington deals with the problem of foreshortening the animal and how he expresses a type of cavalryman by the repetition of mustachioed faces, all in profile.

Theodore Roosevelt wrote of his friend Remington in 1907: "The soldier, the cowboy and rancher, the Indian, the horses and the cattle of the plains, will live in his pictures and bronzes, I verily believe, for all time."

Dismounted: The Fourth Troopers Moving the Led Horses, 1890
Oil on canvas, 34$\frac{1}{16}$ x 48$\frac{15}{16}$ inches
Signed and dated: FREDERIC REMINGTON. / 1890
(No. 11. R.S.C. 1945.)

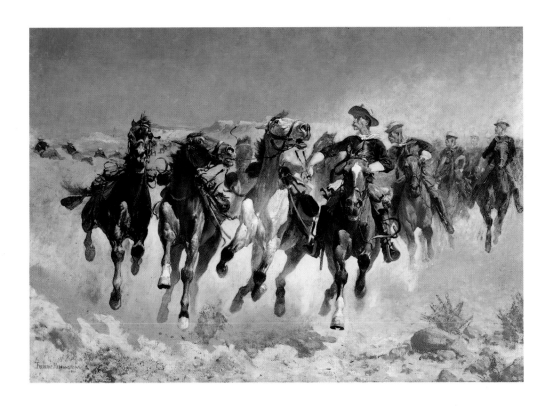

Toilet Set

Thomas Jenkins and the Maker AH English, Seventeenth Century

The last forty years of the seventeenth century were a rich and thriving period in English silversmithing. The Restoration of 1660 had returned a king to the throne of England, steadied a shaken nation, and witnessed the homecoming of exiled aristocrats from the continent. As the political and social climates calmed with the revival of the monarchy, silversmiths found themselves once again in demand. Patrons who had ceased buying silver during the troubled years of the Commonwealth were now anxious to replace plate which had been lost or melted down for currency and to add new articles to their collections.

Comfort and splendor were the order of the day, and new silver wares were created for dining, furnishing, and grooming. In the boudoir toilet sets came into vogue, often comprising a dozen or more items appropriate to a lady's dressing table.

This nine-piece toilet set includes a jewel casket, mirror, four covered boxes, two pomade jars, and a whisk. The various boxes and jars are of octagonal form and are stamped by the prolific Caroline silversmith Thomas Jenkins. The mirror, with its boldly crested frame, bears the maker's mark AH.

The decoration throughout is of a type called *chinoiserie*. Popular during the later seventeenth century and through much of the eighteenth, *chinoiserie* was a by-product of trade with the Orient. Encouraged by Western demand for Eastern goods, European artists and craftsmen began to orientalize their own products, concocting delightful scenes in "the Chinese taste." On English silver wares of the 1670s through the 1690s such imagined scenes were applied in a delicate punched technique called flat-chasing, which is unlike engraved decoration in that no metal is removed. On this toilet set flat-chased foliage, rockery, and birds float and flutter over nearly every surface. The mirror cresting is particularly elaborate, its central fountain surrounded by umbrella palms, swooping birds, and exotic foliage somehow reminiscent of the tropics.

One scholar, Carl Dauterman, has noted the similarity of *chinoiserie* decoration on a variety of English silver forms dating from this period. Although crafted by a number of different silversmiths, these items display remarkably consistent motifs, suggesting the possibility of a single workshop whose specialty was the chasing of *chinoiserie* designs.

Toilet Set, London, 1681
Silver, height of mirror: 22¼ inches
(No. 122. R.S.C. 1941.)

Cup and Cover
Paul de Lamerie English, 1688-1751

Among the treasures of the Institute's holdings in eighteenth-century English silver are thirty-six objects, or sets of objects, by the famous silversmith Paul de Lamerie. The son of French Huguenots who had been forced to flee their native land following the revocation of the Edict of Nantes in 1685, de Lamerie was born in the Netherlands but settled with his family in London by 1691. His apprenticeship at age 15 to the Huguenot silversmith Pierre Platel coincided with a period of increased taste for French styles in England. In fact Huguenot craftsmen were instrumental in transforming the art of English silversmithing at this time, contributing French techniques, motifs, and vessels to the standard English repertoire.

De Lamerie's earliest work reflects the restraint and courtliness of the Queen Anne style, but he is best known for his designs in the rococo idiom. Characterized by lively, delicate, often asymmetrical ornamentation, silver of this period displays a delightful blending of the natural with the fantastic. In addition, a new sculptural dimension was achieved through cast and embossed decoration, seen to advantage on this cup and cover.

Here the basic forms of inverted pear shape cup and double dome cover are nearly obscured by a riot of spirited ornament. Central to the decorative scheme is the infant Bacchus, seated amid vineyards and surrounded by a variety of natural forms. Succulent grapes, vines, and tendrils support the Bacchic theme, while flowers, shells, snails, and lizards reflect the rococo love of natural detail. Two thick, woody vines serve as handles, adorned with twisting tendrils, grape leaves, and snails. Bunches of grapes appear again on the base, afloat in a sea of rococo shells and scrolls. And atop the cover, itself a restless display of flowers, shells, and putti, rests a cluster of grapes crowned by an outstretched lizard.

Certainly such a grand covered cup would have been intended as a presentation piece or ceremonial vessel. De Lamerie repeated this design a number of times, apparently casting the basic forms from the same mold, but varying each version through chasing of the surface and, on occasion, gilding of the entire piece.

Index of Artists

		PAGE
41	AH and Thomas Jenkins, *Toilet Set* (silver)	90
32	Boldini, *Crossing the Street*	72
20	Bouguereau, *Nymphs and Satyr*	48
37	Cassatt, *Woman with Baby*	82
10	Claude Lorrain, *Landscape with the Voyage of Jacob*	28
15	Corot, *The Castel Sant' Angelo, Rome*	38
16	Daumier, *The Print Collectors*	40
25	Degas, *Ballet Dancer Dressed* (sculpture)	58
24	Degas, *The Entrance of the Masked Dancers*	56
23	Degas, *Self-Portrait*	54
42	De Lamerie, *Cup and Cover* (silver)	92
5	Dürer, *Sketches of Animals and Landscapes* (drawing)	18
11	Fragonard, *Portrait of a Man (The Warrior)*	30
12	Gainsborough, *Miss Linley and Her Brother*	32
14	Géricault, *Trumpeter of the Hussars*	36
19	Gérôme, *The Snake Charmer*	46
3	Ghirlandaio, *Portrait of a Lady*	14
6	Gossaert, *Portrait of a Gentleman*	20
8	Hals, *Children with a Cat*	24
34	Homer, *The Bridle Path, White Mountains*	76
35	Homer, *An October Day* (watercolor)	78
36	Homer, *West Point, Prout's Neck*	80
22	Manet, *Moss Roses in a Vase*	52
4	Memling, *The Canon Gilles Joye*	16
17	Millet, *The Knitting Lesson*	42
27	Monet, *The Cliffs at Etretat*	62
28	Monet, *Rouen Cathedral: The Façade in Sunlight*	64
26	Monet, *Seascape: Storm*	60
2	Piero della Francesca, *Virgin and Child with Four Angels*	12
21	Pissarro, *The River Oise near Pontoise*	50
40	Remington, *Dismounted: The Fourth Troopers Moving the Led Horses*	88
31	Renoir, *Bather Arranging Her Hair*	70
30	Renoir, *Onions*	68
29	Renoir, *Sleeping Girl with a Cat*	66
7	Rubens, *Portrait of Thomas Howard, Earl of Arundel* (drawing)	22
9	Ruisdael, *Landscape with Bridge, Cattle, and Figures*	26
38	Sargent, *Portrait of Carolus-Duran*	84
39	Sargent, *A Street in Venice*	86
18	Stevens, *Memories and Regrets*	44
33	Toulouse-Lautrec, *Jane Avril*	74
13	Turner, *Rockets and Blue Lights*	34
1	Ugolino da Siena, *Polyptych*	10

7,000 copies of this edition
designed by Design Studio Inc.
have been printed by
H. T. Woods, Inc.